IMAGES
of America

CONSUMER REPORTS

CONSUMERS UNION reports-

for **MAY 1936**
on

BREAKFAST CEREALS

ALKA-SELTZER

TOILET SOAPS

STOCKINGS

MILK

TOOTHBRUSHES

LEAD IN TOYS

CREDIT UNIONS

Grade A versus Grade B milk
(See page 12)

Published Monthly by Consumers Union of United States

Vol. 1 No. 1

FIRST ISSUE OF CONSUMERS UNION REPORTS, MAY 1936. The first issue of *Consumers Union Reports* included articles on Grade A and Grade B milk, breakfast cereals, soap, and stockings. The magazine adopted a three-tiered ratings scheme—best buy, also acceptable, and not acceptable—to present the scientific test results of the products. The magazine also featured an article on credit unions, which explained why they were better than banks, and one on the efficacy of Alka-Seltzer, which concluded that the product's claims, when analyzed, "vanish like gas bubbles in the air." In 1936, the magazine had a circulation of a little more than 4,000.

IMAGES
of America

CONSUMER REPORTS

Kevin P. Manion
and the Editors of *Consumer Reports*

Published by Arcadia Publishing
Charleston SC, Chicago IL, Portsmouth NH, San Francisco CA

Printed in Great Britain

Library of Congress Catalog Card Number: 2005927370

For all general information contact Arcadia Publishing at:
Telephone 843-853-2070
Fax 843-853-0044
E-mail sales@arcadiapublishing.com
For customer service and orders:
Toll-Free 1-888-313-2665

Visit us on the Internet at http://www.arcadiapublishing.com

This book is dedicated to current and former staff of Consumer Reports:
the many engineers, technicians, statisticians, writers, editors, researchers, advocates,
and other professionals who have toiled over many decades to help create a safer and
more just marketplace for consumers. We have borrowed their thoughts, their images,
and their words to create this testimonial to their dedication and hard work.

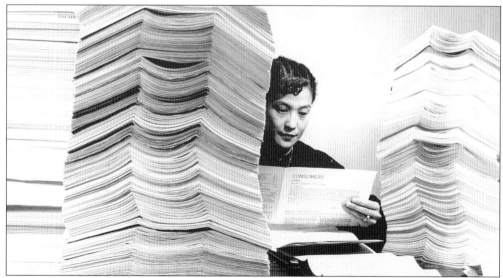

COMPILING RESULTS OF THE ANNUAL QUESTIONNAIRE, 1959. In this photograph, a staff member compiles responses from the annual questionnaire sent out by *Consumer Reports*. Today over 900,000 completed questionnaires are returned to *Consumer Reports* either in hard copy or online. The questionnaire covers multiple topics, including automobile reliability, automobile owner satisfaction, and appliance and electronics reliability. It also covers subscribers' satisfaction and their experiences with services on topics that vary from year to year.

CONTENTS

ACKNOWLEDGMENTS

The author wishes to acknowledge his colleagues in the Information Center for their support during the production of this book. The author also wishes to thank Paige Amidon, Sambhavi Cheemalapati, Elena Falcone, Dan Franklin, Jim Guest, Sandy Byers Harvin, Martin Kagan, Bob Karpel, Carol Lappin, James MacDonald, Sandy Monteleone, Ariane Orenstein, Roberta Piccoli, Jennifer Shecter, and John Walsh for helping to make this book possible. Thanks also go to design director George Arthur and his staff for production help.

Special thanks to my parents, Richard and Marie Berthe Manion, who made me understand the value of education early on, and to Jonathan Bronsky, without whom this book would not have been possible, for his unwavering support.

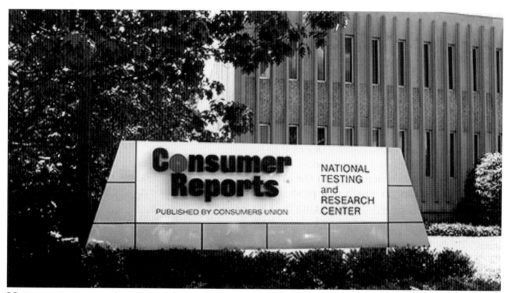

HEADQUARTERS OF CONSUMER REPORTS. *Consumer Reports* moved its headquarters to Yonkers, New York, in 1991. Today Consumer Reports' National Testing and Research Center houses 50 state-of-the-art laboratories in a 250,000-square-foot facility. Consumers Union is the parent of Consumer Reports, the testing and publishing arm of the organization.

INTRODUCTION

For seven decades, *Consumer Reports* has helped millions of consumers navigate the dizzying array of marketplace choices. Clearly those choices have changed through the years and, in many ways, grown more complex. In our first issue in 1936, we explored whether or not the 3¢ difference between Grade A and Grade B milk was justified, investigated the staying power of women's stockings, tested the cleansing power of toothbrushes, and evaluated the soothing power of Alka-Seltzer. Back then, we were an organization that had big dreams of changing the world through objective, scientific research. Unfortunately, we did not have a big testing budget to match, so we did the best we could with a small, yet ingenious and entrepreneurial staff.

Today I am proud to say that that has changed. Thanks to our millions of dedicated readers, we now have the resources to do far more than our talented, pioneering founders could ever have imagined possible. If they were here today, they would surely smile in wonder at the 50 state-of-the-art laboratories and 327-acre automobile test center we have built on their solid foundation to serve no one and nothing but the consumer interest. And, through it all, we have never wavered from our bedrock values of independence and integrity, having never accepted any advertisements or freebies of any kind.

In our tireless efforts to improve the buying habits of the American household, *Consumer Reports* has become a household name, synonymous with trust and credibility. This book of photographs is a compelling testament and celebration of *Consumer Reports'* journey from cultural ideal to cultural icon.

It is also worth noting that some of these photographs are well traveled. From the corridors of Congress to the rooms of our nation's regulatory agencies, several of these pictures spoke louder than any words to help convince lawmakers to better serve the safety of the American public. At the end of the day, Consumers Union, the nonprofit publisher of *Consumer Reports*, is more than just a research and testing organization that helps inform purchasing decisions. It is an organization that uses its findings to inform policy decisions and advocate for change in the consumer-protection landscape.

Ultimately, this collection of vintage photographs represents the collective history and evolution of the American marketplace. The pictures illustrate just how much progress consumer products have made when it comes to how safe they are, how well they work, and how long they last. It is almost impossible to think of a time when some of our most beloved home appliances and cars were also the most dangerous—irons overheated, microwaves leached radiation, television sets easily caught fire, and safety belts failed to secure drivers in a crash. It is also unreal to think about a time when the latest technological innovations consisted of the transistor pocket radio and the automatic record changer—not quite the iPods and high-definition television systems of today.

But that is the beauty of *Consumer Reports*. During every period since 1936—in times of war and in times of peace, through the economic booms and the market busts—we have been advising consumers on which new products and services were worth their hard-earned dollars and which were not worthy of attention. This book is a powerful visual compilation of that advice through the ages and a reminder of just how far *Consumer Reports*—and in the end, all of American society—has come.

—Jim Guest
President and CEO

CONSUMER REPORTS CELEBRATES ITS 50TH ANNIVERSARY, 1986. In 1986, *Consumer Reports* participated in two exhibits as part of the celebration to mark the 50th anniversary of the founding of the organization. The first (above), entitled *Milestones: 50 Years of Goods and Services*, was presented at the Cooper-Hewitt Museum in New York City. The second (below) was displayed at the Smithsonian's National Museum of American History in Washington, D.C., and entitled *The Consumer Movement in America: Citizen Action in the Marketplace.*

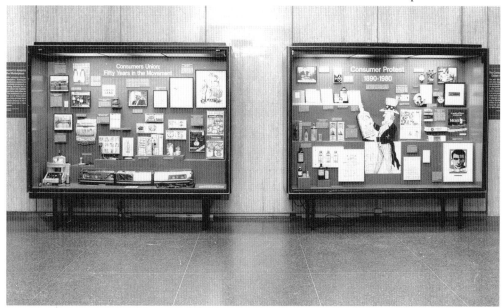

One

A NEW VOICE

STATE OF NEW YORK

DEPARTMENT OF STATE

ALBANY

IT IS HEREBY CERTIFIED THAT THE

Certificate of Incorporation

of

Consumers Union of United States, Inc.

was filed in this Department on the *sixth* day of *February, 1936.*

Witness my hand and the official seal of the Department of State at the City of Albany this 6th day of February, 1936.

Edward J. Flynn

Secretary of State

CHARTER OF CONSUMERS UNION GRANTED BY THE STATE OF NEW YORK. On February 22, 1936, a small group of people met in an office in midtown Manhattan to discuss the charter their organization had obtained a few weeks earlier from the State of New York. The new organization, called Consumers Union, would provide consumers with "information and counsel on . . . goods and services" and "maintain laboratories . . . to supervise and conduct research and tests."

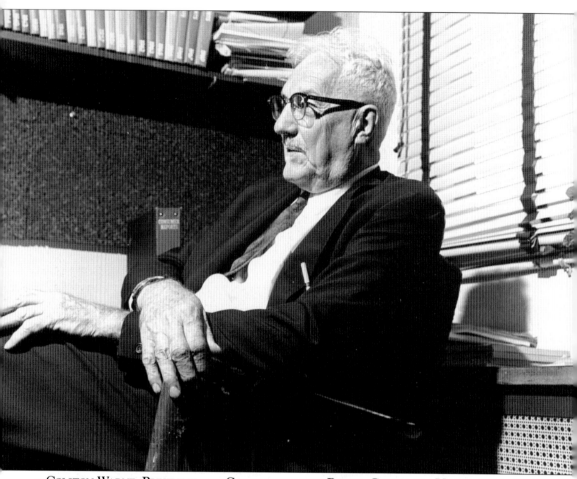

Colston Warne, President and Chairman of the Board, Consumers Union, 1936–1980.
Founded in 1927, Consumers Research (a predecessor to Consumer Reports) grew out of a consumer club that engineer Fred Schlink had organized in White Plains, New York. The organization reproduced a list of products that were considered to be a good value and products that were to be avoided because of price, inferior quality, and false or misleading advertising and created a magazine that bore its name. The publication was the first magazine devoted to testing consumer products. In 1935, Schlink moved Consumers Research to a new location 100 miles outside of New York City to the then rural village of Washington, New Jersey. He needed more space to build his own testing facilities and thought that anyone who mattered in the consumer movement would be willing to come to him. Colston Warne later wrote, "For the first few months, the situation was idyllic. New Yorkers had always craved an outpost in the country. This was, however, the greatest error in Schlink's career." In September 1935, disenchanted with rural life, low pay, and tough working conditions, three workers attempted to form a union and were fired for their efforts. Some 40 workers walked out on strike. Schlink reacted by hiring armed detectives and strike breakers and accused the strikers of being "Reds." By the end of 1935, with no end in sight, strikers from Consumers Research began to think about starting another organization. In February 1936, the State of New York granted a charter to Consumers Union, with the goal to provide consumers with "information and counsel on . . . goods and services" and to "maintain laboratories . . . to supervise and conduct research and tests." Arthur Kallet, a former director of Consumers Research who had joined the strikers, was appointed executive director of the new organization.

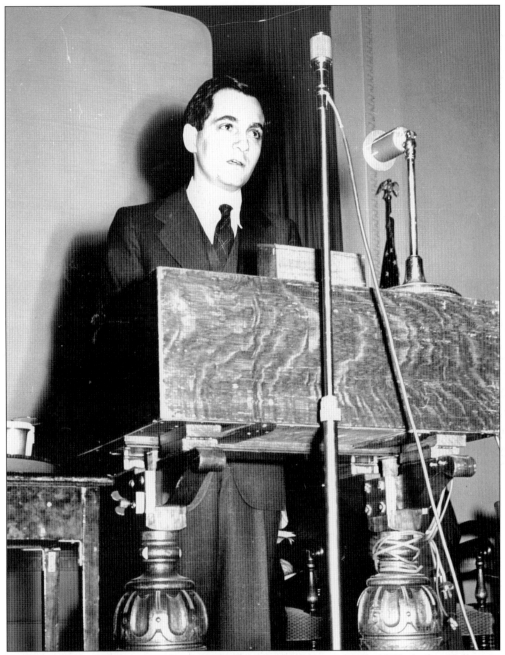

ARTHUR KALLET, EXECUTIVE DIRECTOR, CONSUMERS UNION 1936–1957. Arthur Kallet was the coauthor of an early work on consumerism entitled *100,000,000 Guinea Pigs*, which became a best seller in the early 1930s, selling more than 250,000 copies. He saw Consumers Union through the difficult war years and through lingering accusations of communist activity.

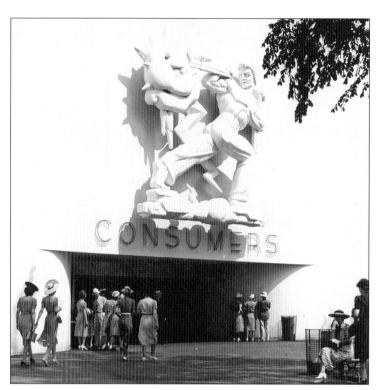

CONSUMER REPORTS AT THE WORLD'S FAIR, AUGUST 1939. The August 1939 issue of *Consumer Reports* invited readers to visit the 1939 World's Fair in New York City where the organization held an exhibit in the Consumers Building. The exhibit included guinea pigs, reminding consumers that they did not have to be guinea pigs in the marketplace. A book published a few years earlier on the consumer movement and coauthored by Arthur Kallet had used the same allusion.

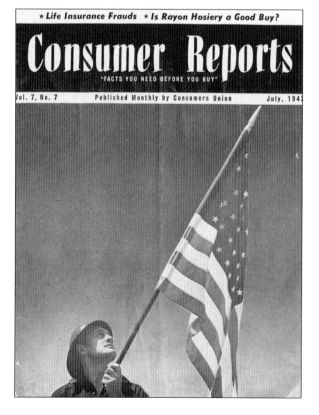

CONSUMER REPORTS, JULY 1942. As part of an initiative organized by the National Publishers Association (now the Magazine Publishers of America), *Consumer Reports* joined other publications across the country in featuring the flag on its July 1942 cover. This cover was included in a recent Smithsonian exhibit commemorating the effort by American publishers. In December 1938, *Consumer Reports* had called on its readers to boycott products from Germany, citing Nazi violence.

CONSUMER REPORTS IS MOVING, SEPTEMBER 1954. The text that accompanied this photograph in 1954 read, "The organization that started out in 1936 in one room in a New York City office building and has since expanded to occupy eight floors in two widely separated buildings will be reconsolidated in one building in Mount Vernon. . . . Besides bringing together all operations in a single plant, the move to our own building will make possible expansion and improvement of our laboratory facilities."

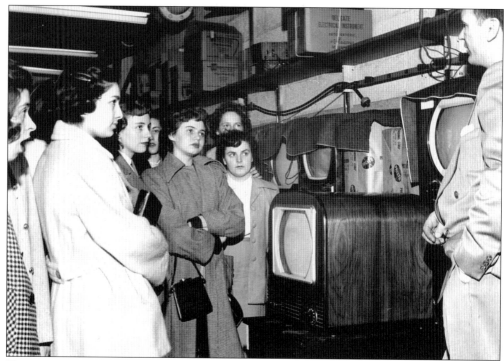

TOURS OF CONSUMER REPORTS, 1954. Tours have always been an important part of reaching out to *Consumer Reports* readers. In these two photographs taken in 1954, guests tour a laboratory where televisions are tested and where washing machines are put through the wringer. Every fall at the annual meeting, hundreds of members take tours around the laboratories and view testing demonstrations in Yonkers, New York.

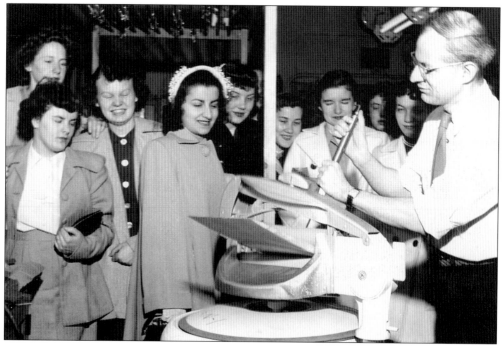

THE FOUNDING OF INTERNATIONAL ORGANIZATION OF CONSUMERS UNIONS, APRIL 1960.
April 1, 1960, represented a landmark in the development of the worldwide consumer movement. At a meeting in The Hague, delegates from 16 consumer organizations representing 14 countries founded the International Organization of Consumers Unions (IOCU) and selected *Consumer Reports'* Colston Warne, who spearheaded IOCU's creation, as its first president. The mission of the organization was to act as a central clearinghouse of ideas, test methods, and test results. A formal announcement was made in Paris a few days later at a conference on testing sponsored by the Organization for European Economic Cooperation. Today a renamed IOCU, Consumers International (www.consumersinternational.org), has a membership of over 250 organizations in 115 countries and strives to promote a fairer society through defending the rights of all consumers, especially the poor, marginalized, and disadvantaged. Below are some early-1980s publications of member organizations.

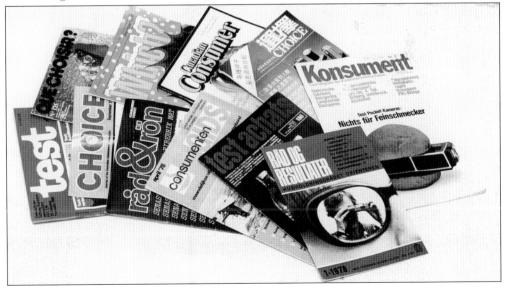

WESTERN UNION

TELEGRAM

W. P. MARSHALL, PRESIDENT

1220
(R 11-54)

The filing time shown in the date-line on domestic telegrams is STANDARD TIME at point of origin. Time of receipt is STANDARD TIME at point of destination

SYA293

SY WWA375 GOVT PD=WUX THE WHITE HOUSE WASHINGTON DC 12
520P EST=

DR COLSTON E WARNE=

CONSUMERS UNION MT VERNON NY=1 1961 APR 12 AM 5 37

IN A PERIOD IN WHICH TOO FEW VOICES SEEM TO HAVE BEEN
RAISED IN THE INTERESTS OF THE CONSUMER, CONSUMERS UNION
HAS FOR TWENTY FIVE YEARS PROVIDED ITS UNIQUE TESTING
SERVICES ON THE QUALITY OF PRODUCTS AND GIVEN ADVICE AND
COUNSEL OF WISDOM AND FAIRNESS, NOT ONLY TO CONSUMERS
DIRECTLY, BUT TO INDUSTRY AND GOVERNMENT, ITS WORK HAS
CONTRIBUTED TO THE STRENGTH OF OUR FREE ECONOMY AND TO THE
WELL-BEING OF ALL AMERICANS. THE CONSUMERS UNION ENJOYS
BROADER SUPPORT THAN EVER BEFORE BECAUSE IT HAS ALWAYS
SOUGHT TO MEET IDEALS OF THRIFT. YOU HAVE PLAYED A
SIGNIFICANT ROLE IN EXPANDING THE HORIZONS OF AN INFORMED
PUBLIC. WITH EVERY BEST WISH=
JOHN F KENNEDY.

TELEGRAM FROM PRES. JOHN F. KENNEDY, APRIL 12, 1961. This is a telegram from Pres. John F. Kennedy on the occasion of the 25th anniversary of Consumers Union.

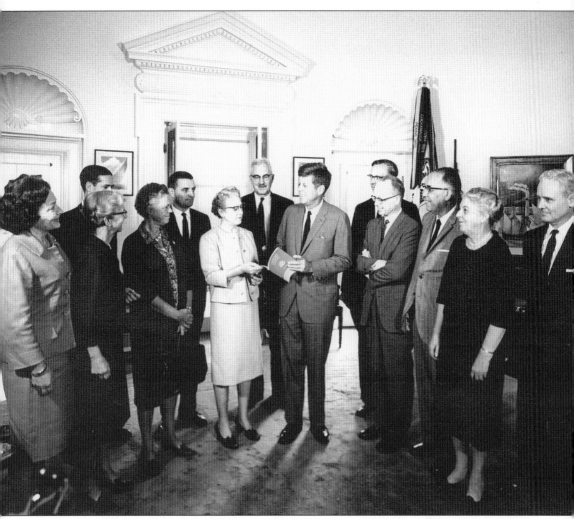

COUNCIL OF ECONOMIC ADVISERS, CONSUMER ADVOCACY COUNCIL, OCTOBER 8, 1963.
Consumers Union president Colston Warne (to the left of Kennedy) joins colleagues of the council
for a meeting with Pres. John F. Kennedy. (Photograph courtesy of the John F. Kennedy Library.)

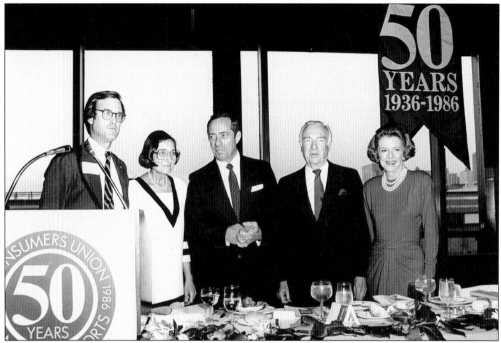

CONSUMERS UNION'S 50TH ANNIVERSARY DINNER. At a 1986 dinner hosted to mark the 50th anniversary of Consumers Union, New York governor Mario Cuomo (above, center) stated, "Consumers Union passes the test of 50 years with a rating of excellent." Guests at the dinner included staff members, consumer leaders from around the world, and friends and members of Consumers Union. Seen above are, from left to right, Jim Guest, chairman of the board (1980–2000) and president and CEO of Consumers Union (2001–present); Rhoda Karpatkin, president and executive director of Consumers Union (1974–2001); Mario Cuomo; Walter Kronkite; and Betty Furness, secretary of Consumers Union's board. Below, Esther Peterson, special assistant for consumer affairs to Presidents Johnson and Carter and a longtime friend of Consumers Union, joins Jim Guest and Rhoda Karpatkin at the podium to address the 800 guests assembled for the event. Peterson presented a framed copy of a congressional resolution honoring Consumers Union.

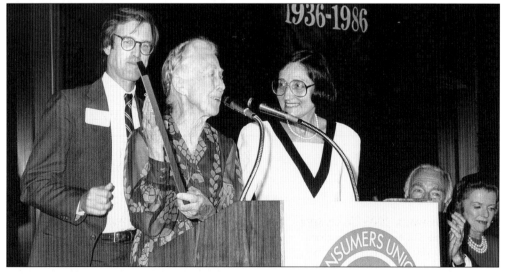

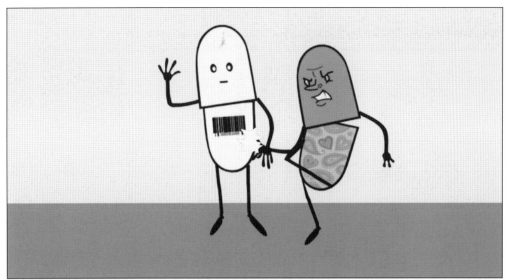

PRESCRIPTION FOR CHANGE CAMPAIGN, 2005. Consumers Union is also involved in a number of important national advocacy campaigns such as Prescription for Change, which is aimed at ensuring safe, effective, and affordable prescription drugs; Hear Us Now, which works to ensure consumers have clear telecommunication choices; Financial Privacy Now, which safeguards consumers against identity theft; Safe Cars for Kids, which advocates for enhancing vehicle safety to protect children from deadly automobile hazards; and Stop Hospital Infections, which promotes patient safety through public disclosure of infection rates. The above image was part of an innovative approach to the Prescription for Change campaign. The Austin Lounge Lizards provided the sound track to an animation, which through humor made the point that affordable prescriptions should be available to all consumers.

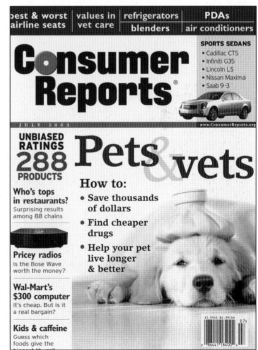

MOVING FORWARD, 2003 CONSUMER REPORTS REDESIGN. The cover story on "pets and vets" won the magazine a prestigious National Magazine Award.

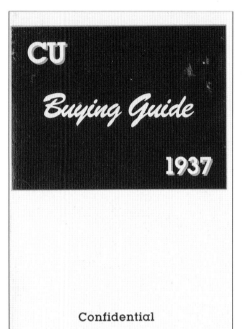

THE 1937 BUYING GUIDE. The first buying guide was published in 1937 and has been published every year since. The confidentiality note on the cover resulted from a serious concern that potential lawsuits from manufacturers whose products did not rate well would have drained the young organization's resources.

Vol. 1, No. 1 FEB. 25, 1941

Bread & Butter
"FACTS YOU NEED BEFORE YOU BUY"

Published weekly and copyright, 1941, by Consumers Union of United States, Inc., a non-profit organization. Application for entry as second class matter is pending. Rates: $1 a year; in combination with Consumers Union Reports and Buying Guide, $4; single copies, 5c. Address all correspondence to Consumers Union, 17 Union Square, N.Y.C. (time does not permit answers to inquiries for special information).

Bread & Butter is published to help consumers protect their living standards by providing them with up-to-date, reliable information about what is happening to the prices and quality of consumer goods. The information presented is compiled from all available sources: the trade press, commodity and wholesale markets, government and industrial reports, interviews with trade specialists.

All information given has been carefully checked, but it can make no claim to be infallible. Specific brand recommendations in this report are based on tests and examinations conducted by Consumers Union and taken from Consumers Union Reports and Buying Guide.

THIS WEEK'S HIGH POINTS
- ★ **Wool Goods Continue Rising**
- ★ **"Voluntary Rationing" Foreshadows Scarcity**
- ★ **Plastics Take the Place of Metals in New Household Appliances**
- ★ **Profiteers Dip into the Lard Bucket**
- ★ **Don't Buy Money**
- ★ **Hidden Price Increases are Widespread**

● Prices are going up. That's common knowledge. The big questions are: why, how much, and when.

Great surpluses of the goods out of which we make nearly everything we eat and wear still exist. With very few exceptions, there is no reason or need for price rises.

Except for metals, defense buying will take only a small part of available goods and machinery. Army orders for shoes this year, for example, total less than 7% of the men's shoes produced.

Why, then, are prices going up?

● The answers are five:

Speculation: More than a year ago the speculators began buying up goods that would be needed for the Army and Navy. *Today speculators are buying civilian goods as well.*

Commercial hoarding: Warehouses are filling up. Financial papers are already concerned about a shortage of warehousing space. Large packers, chain stores, and big manufacturers are *holding supplies of consumer goods for higher prices.*

Monopoly: Assistant Attorney General Thurman Arnold stated last week that in at least *thirty-one industries there were evidences "of price increases, artificial shortages, and foreign control" that have resulted from monopoly practices.*

Voluntary rationing: That's a new phrase now becoming popular in business circles. It means simply that manufacturers are refusing to expand their plants or reorganize their businesses for more efficient operation in order to fill orders from both their usual customers and the government. By keeping the supply of goods down, they figure they can make more money, easier and quicker. They are, in other words, now *preparing the ground for big price increases in the future when the defense program has absorbed a significant part of the unemployed, thereby creating larger demand.*

Business-as-usual: "Charge all the market will bear" has always been one business principle; not what a thing costs, but what you can get for it, determines price. With more people at work, business reasons, there will be more to get out of them.

Under the headline, "Whiteside Urges Business Look More to Profit Angle," the *Daily News Record* (retail trade paper) last week reported some business advice from Arthur D. Whiteside, president of Dun & Bradstreet, and now a member of the National Defense Priority Board. "This is no time," said Arthur D. Whiteside, "to give goods away and a very good time to select customers on which there is good reason to feel a profit may be made."

● How much prices will go up, and when, are questions that can only be answered, week by week, and through a careful consideration in each case of: (1) the extent of monopoly controls in the

BREAD AND BUTTER. Published during World War II and until 1947, the weekly *Bread and Butter* newsletter was intended to help consumers deal with the limited resources that resulted from rationing.

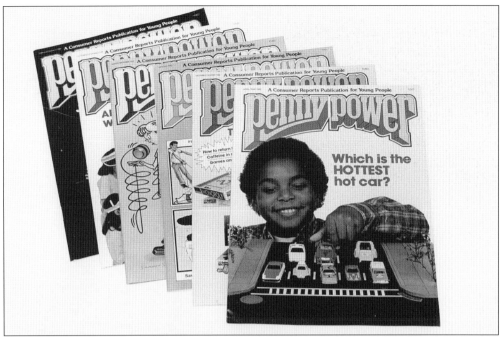

PENNY POWER. Aimed at educating younger consumers to prepare them for the marketplace, *Penny Power* (later renamed *Zillions*) made learning fun through games and puzzles. Reports focused on topics such as what backpacks, video games, and snack foods to buy and how to save money from a summer or part-time job.

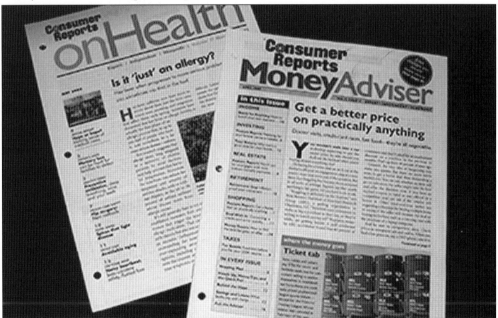

HEALTH LETTER AND MONEY ADVISER. In 1989, Consumer Reports started a consumer-oriented health newsletter called *Consumer Reports Health Letter* (now *Consumer Reports on Health*). In 2004, Consumer Reports created a personal finance newsletter to help consumers wade through the often confusing world of investing, among other personal financial issues.

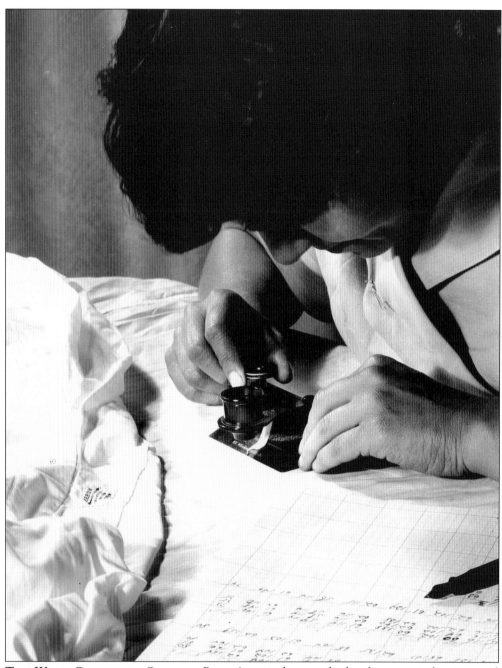

THE WORK CONTINUES. *Consumer Reports'* meticulous methods of testing, informing, and protecting continue today in the same manner as when this 1949 picture was taken, showing a technician keeping careful laboratory notes. Today, with almost seven million subscriptions, *Consumer Reports,* www.consumerreports.org (the largest subscription-based Web site in the world), *Consumer Reports on Health,* and the *Consumer Reports Money Adviser,* in addition to other online and print publications, continue to provide consumers with sound advice and information.

Two

APPLIANCES

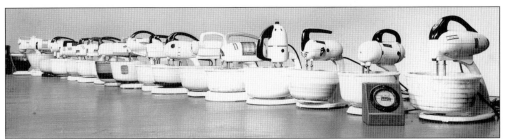

FOOD MIXERS, JUNE 1953. Of the 17 models tested, two food mixers were found to be outstanding and five were not acceptable (mostly they rated poor on durability). The appliances were judged on factors including mixing (cake batter, heavy batter) and mashing potatoes. Convenience features such as speed controls, beaters, portability, variety of attachments, and, of course, durability were also assessed.

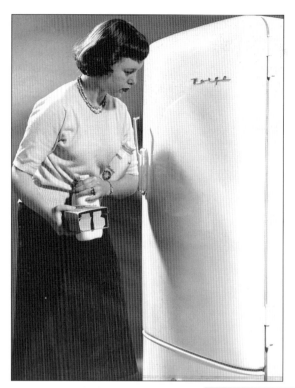

REFRIGERATORS, JUNE 1949. The Norge model was the only refrigerator equipped with a handle that could be nudged open with an elbow while both hands were full. This 1949 report included information for readers who lived in areas that were served by direct current and on the importance of grounding any large appliance to avoid electric shocks.

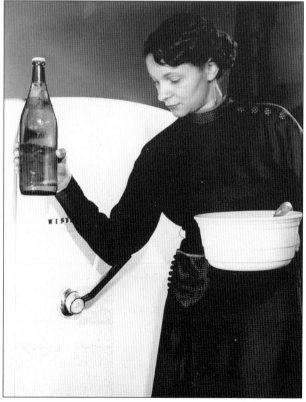

REFRIGERATORS, JANUARY 1952. Westinghouse's design enabled owners to open the refrigerator door while both hands were full. In this report, testers evaluated a new model, an across-the-top type (first tested in October 1951); two others with cold-wall construction; and models with automatic defrosting. The across-the-top model had a freezer with 1.2 cubic feet of space compared with the more common "u-type" freezer of the time, which featured only a 0.7-cubic-foot freezer.

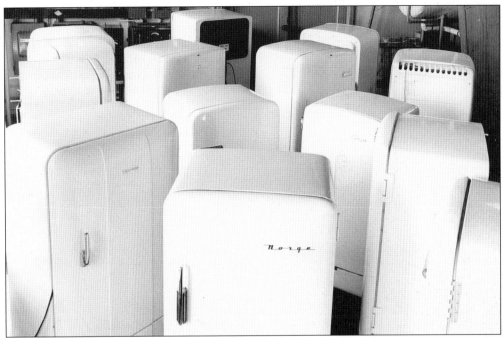

REFRIGERATORS, JUNE 1949. Among the refrigerators that were tested (ranging in price from $174.95 to $299.95), eight were judged acceptable and two not acceptable. The two that were deemed not acceptable presented problems such as an inability to maintain a proper temperature and awkward design.

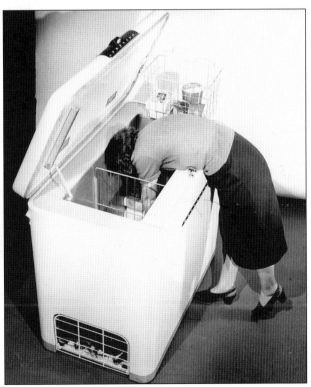

FREEZERS, APRIL 1952. Compared with today's units, the freezer in this picture has incredibly thick walls. In this report on small freezers (6 to 7.2 cubic feet), several of the units tested were judged inconvenient to unload because of the long reach to the bottom. The prices of the freezers ranged from $224.95 to $299.95. The monthly cost of electricity needed to operate the freezers was between $1.70 to $2.35 (calculated at an average 3¢ per kilowatt hour).

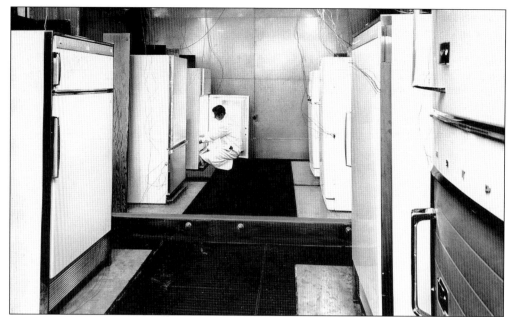

REFRIGERATORS, AUGUST 1957. This refrigerator report included an explanation of the temperature-measuring process used during testing. The refrigerator performance tests were conducted in this temperature-controlled room. Refrigerators were operated at room temperatures of 70, 90, and 110 degrees Fahrenheit. Throughout the test run, sensors inside each closed refrigerator measured temperatures and transmitted the information to an external recording device. Sensors were placed in frozen-food packages in various parts of the fully loaded freezers (as shown below in 2003), while others were placed in the main space of the refrigerator and door shelves.

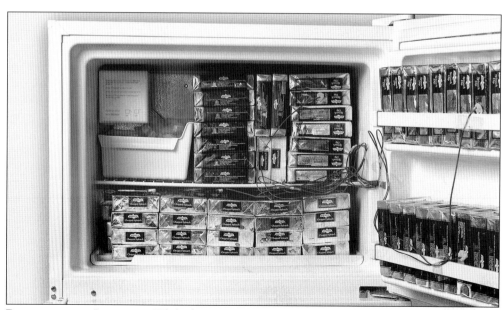

REFRIGERATORS, JULY 2003. While the testing equipment, design, and efficiency of refrigerators has changed dramatically, temperature is still tested by placing sensors inside freezers and refrigerators.

WASHING MACHINES, JUNE 1950.
These two photographs show a test of
nonautomatic washing machines that
resulted in half of the 20 models being
rated not acceptable. The Maytag N2LP
(right) was judged one of the safest.
Other models were criticized because
of the wringer safety release, which was
difficult to use or inconveniently located.

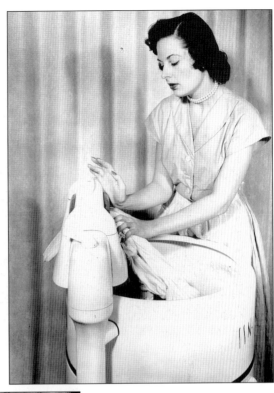

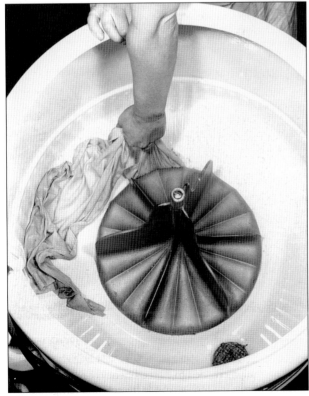

**WASHING MACHINES, JUNE
1950.** The Ward model (left)
was also judged not acceptable
because clothes became stuck
under the agitator during testing.

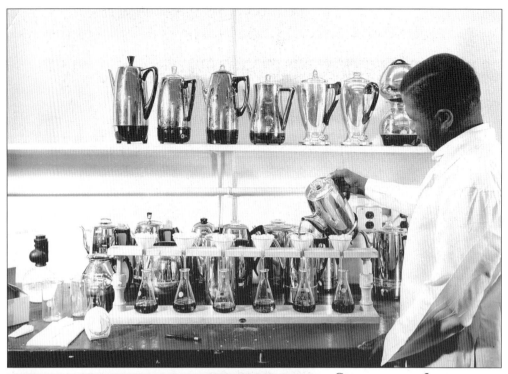

COFFEEMAKERS, JANUARY 1958. This test of 21 coffeemakers involved assessing the solids in brewed coffee, brewing time, electricity used, and convenience features. The lid of this percolator, a Sunbeam model, fell off when the last cups were poured.

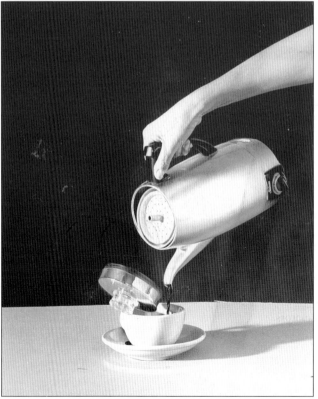

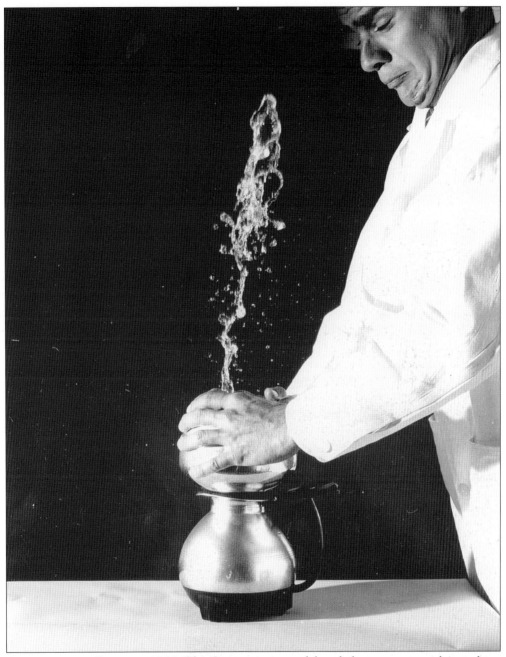

COFFEEMAKERS, JANUARY 1958. The Cory vacuum model took force to operate, but pushing too hard could result in water spurting out. This model was judged comparable in overall quality to the lowest-rated acceptable percolators.

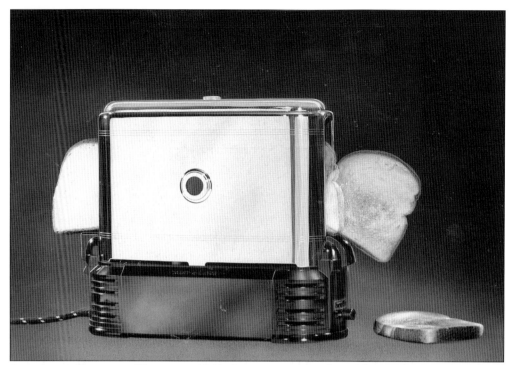

AUTOMATIC TOASTERS, NOVEMBER 1949. An interesting but flawed design, this toaster "walked" pieces of bread through, toasting one after the other. It was slow in operation (taking three and two-thirds minutes to toast two pieces of bread), top-heavy, and difficult to carry. Replacing the casing on the toaster after it had been removed for cleaning also proved to be difficult.

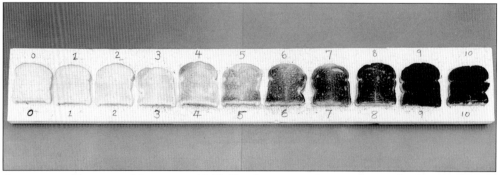

AUTOMATIC TOASTERS, NOVEMBER 1949. For this test, technicians created reference slices of toast using eight of the ten slices pictured here. Toasters that could produce five or six shades were described as having average color range. Some produced as few as three, others as many as seven.

AUTOMATIC ELECTRIC TOASTERS, MAY 1956. Three million toasters were sold in 1955. At the time, a toaster could be found in three out of four American homes that were wired for electricity. This report stated that, next to the electric clock and electric iron, the toaster was the most common small home appliance. During the testing of the 22 models for this article, hundreds of pieces of bread were toasted. Many of the toasters were defective and some were even hazardous. Only three brands ranked high in quality.

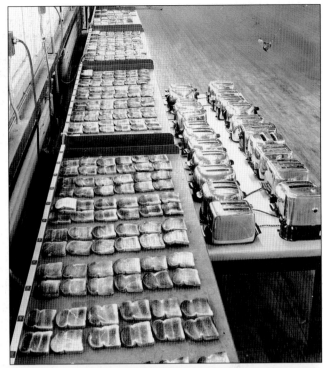

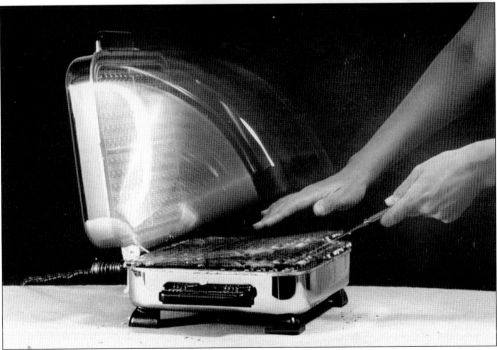

WAFFLE IRONS, SEPTEMBER 1957. Of the 18 models tested in 1957, seven models were judged not acceptable, including the one pictured above. The lid of this model slammed shut if jarred only slightly. Among other problems, testers found unshielded terminal pins that could cause shocks and a handle so close to the base of the unit that using it just about ensured a burn.

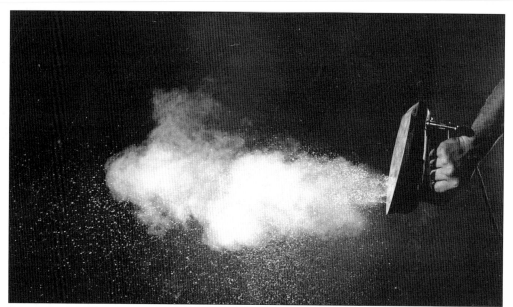

STEAM IRONS, OCTOBER 1951. When the Steam-O-Matic (above) was emptied while hot, in accordance with the manufacturer's instructions, hot water and steam spurted through vents in the toe of the soleplate. Home economists who assisted in the testing in 1951 judged this a hazard, and the iron was rated not acceptable.

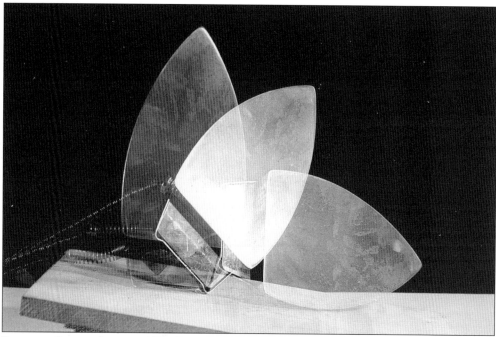

ELECTRIC IRONS, AUGUST 1951. During testing, irons were subjected to an eight-degree tilt to assess stability. Irons, like this one, that had a tendency to topple over when tilted were judged not acceptable.

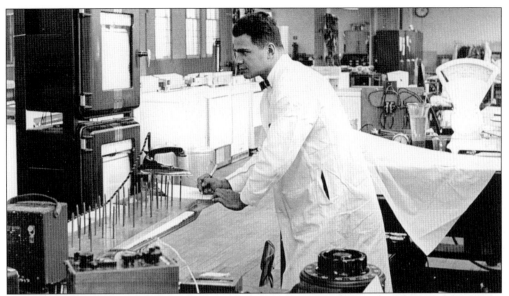

ELECTRIC IRONS, MARCH 1958. Sensors provided accurate information on the iron's performance at various settings of a thermostat. Although the tests included 33 irons (steam and dry), the report stated that steam irons were quickly outselling dry irons at a rate of three-to-one. In 1957, 7.5 million total units were sold in the United States.

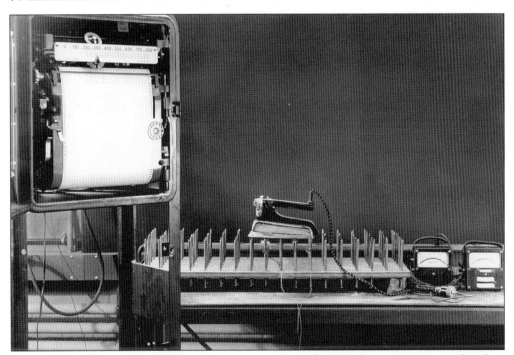

STEAM IRONS, FEBRUARY 1961. During testing, each sample's soleplate temperature and cycling characteristics were measured with the aid of the recording instrument on the left, while meters on the right measured power consumption. This 1961 test also discussed the differences between boiler irons, which continue to steam as long as there is water in the iron, and drip irons, which provide control over the steam.

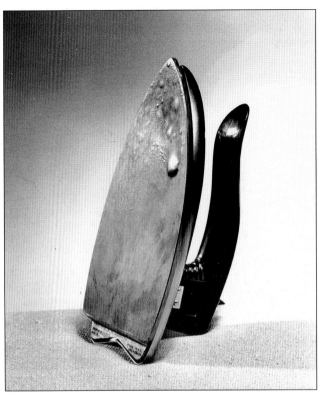

TRAVEL IRONS, JUNE 1960.
Of the 11 models rated in this
test, 9 presented various burn,
shock, and fire hazards. Two
Durabilt models, including the
402 model (left), were judged
to be hazardous. After only
10 minutes, the aluminum
soleplates were so hot that they
began to deform and melt.
All the Durabilt models had
handles that could potentially
fold while in use (below),
bringing the users hand in
direct contact with the hot
iron surface. *Consumer Reports*
found them not acceptable.

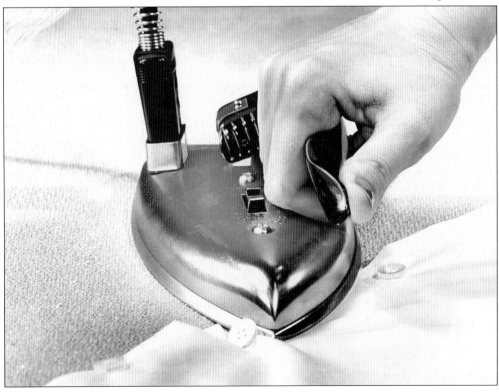

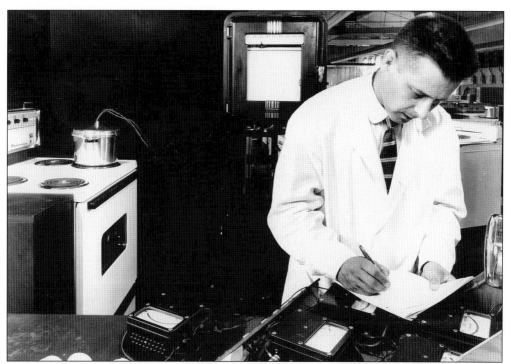

REPORT ON ELECTRIC RANGES, SEPTEMBER 1958. In this photograph, a technician monitors a water-heating test. Electrical supply and consumption were measured by the instruments in the foreground while the device at rear recorded the rate at which the water was heated.

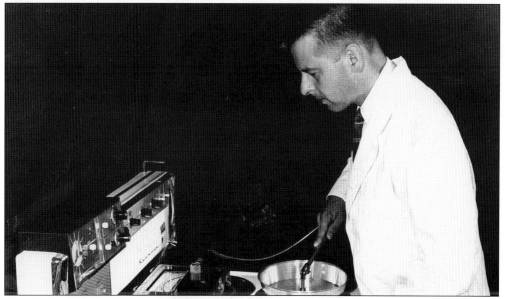

REPORT ON ELECTRIC RANGES, SEPTEMBER 1958. In another test conducted for the same report, a technician used a pyrometer and a stopwatch to determine how long each range took to heat an empty nine-inch frying pan to 400 degrees Fahrenheit. The device also recorded instances when the temperature went over 400 degrees Fahrenheit and the length of time it took for the range to cool down.

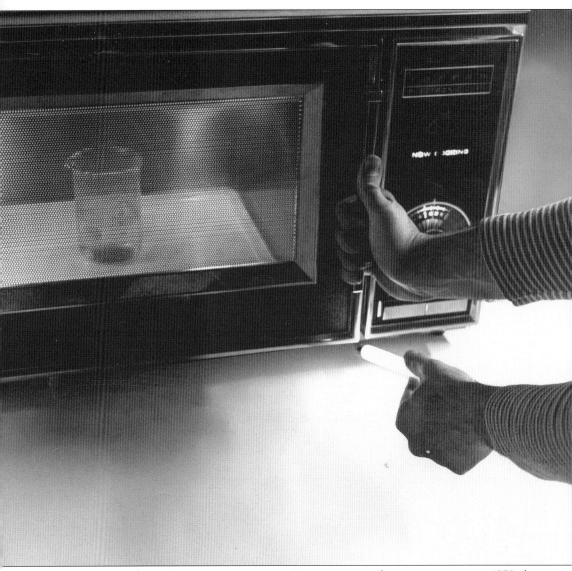

MICROWAVE OVENS, APRIL 1973. *Consumer Reports* expressed serious concerns in 1973 about radiation leakage in microwave ovens. While ovens met federal standards on delivery, tugging on the door or inserting a paper towel in the door and shutting it created leaks far beyond acceptable levels. A home testing device—the Micro-Detector, which sold for $9.95—was anything but sophisticated and did not work any better than holding a simple fluorescent bulb near the microwave door. The bulb grew brighter as leakage increased.

ELECTRIC DISHWASHERS, NOVEMBER 1952. The introduction to this test stated that dishwashers could lighten the work of washing dishes but they did not take all of the work out of this daily chore. At the time, it was estimated that women spent about an hour and a half per day doing dishes. The Kitchen Aid model (right) rated well for dish-washing ability and for overall convenience.

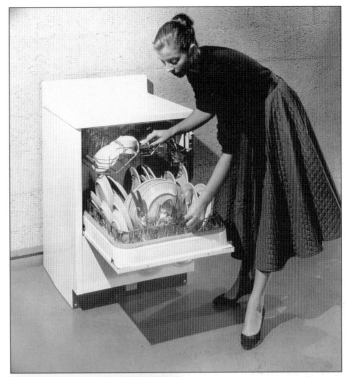

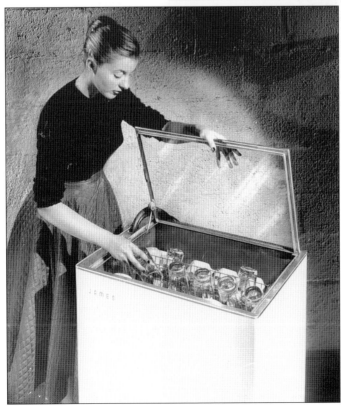

ELECTRIC DISHWASHERS, NOVEMBER 1952. The James model (left), which was considered portable and had a glass top, allowing consumers to see the washing process, received only a fair rating and was difficult to clean.

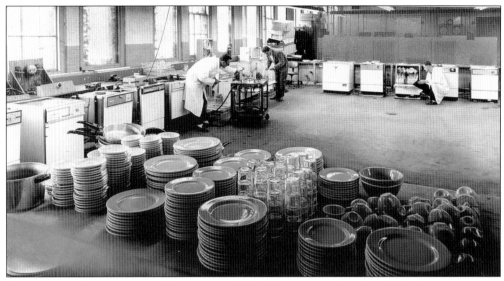

AUTOMATIC DISHWASHERS, NOVEMBER 1962. Ten years after the 1952 dishwasher tests (pictured on the previous page), *Consumer Reports* noted great improvements in the versatility and effectiveness of this relatively new appliance. While the photograph above shows stacks of cups, plates, and glasses, the article stated that testers were unable to load any of the machines with as many place settings as their manufacturers claimed.

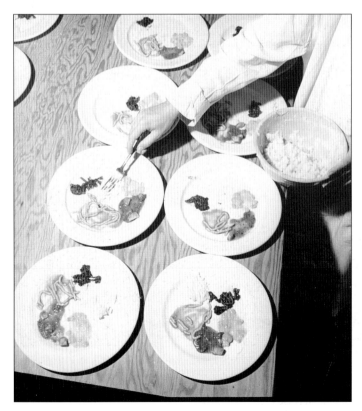

AUTOMATIC DISHWASHERS, NOVEMBER 1962. A sidebar explanation of the testing process stated that while the *Consumer Reports'* tests are tough, they are also realistic. Dishes were soiled with egg yolk, spaghetti, mashed potatoes, cereals, cigarette ashes, and other substances. After standing for 30 minutes, the dishes were lightly scraped to remove only bulk soil, and glasses and cups were emptied of excess liquid before being loaded into the appliances.

Three

FOOD

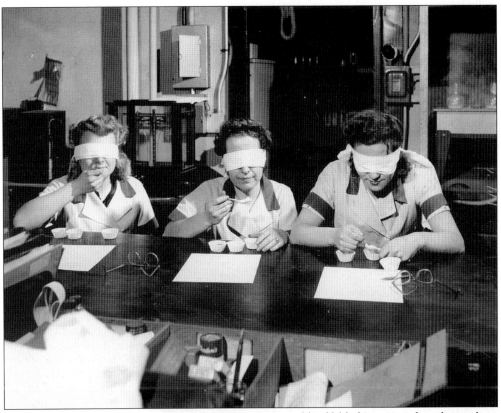

PUDDINGS AND GELATIN DESSERTS, APRIL 1945. A blindfolded test panel is shown here sampling gelatins and puddings for taste. Tests found that the taste varied considerably from one brand to another. The article stated that these packaged deserts allowed "the busy housewife to whip together a more-or-less tasty dessert in very few minutes."

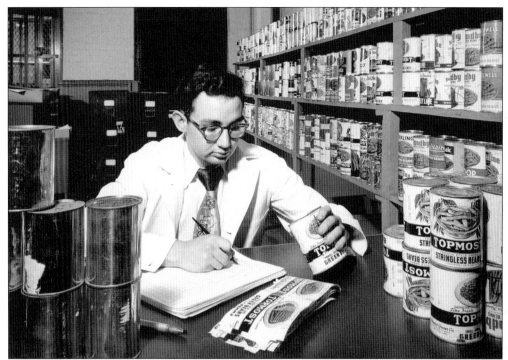

CANNED GREEN BEANS, SEPTEMBER 1950. Canned goods that had been shipped from shoppers all over the United States were brought to the coding room where original labels were removed and cans were re-labeled with code numbers to mask the products' identities from testers. To this day, taste testers at *Consumer Reports* are never aware of the brands that they are tasting.

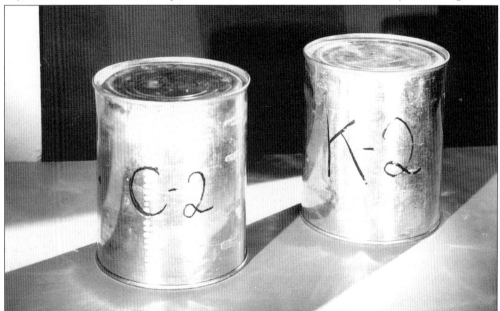

LABELING, GRADE VERSUS DESCRIPTIVE, NOVEMBER 1937. Two cans of pears are stripped of their labels and coded for testing. The tests were meant to assess the grade listed on the label. Testers found that the least expensive canned pears often rated the highest.

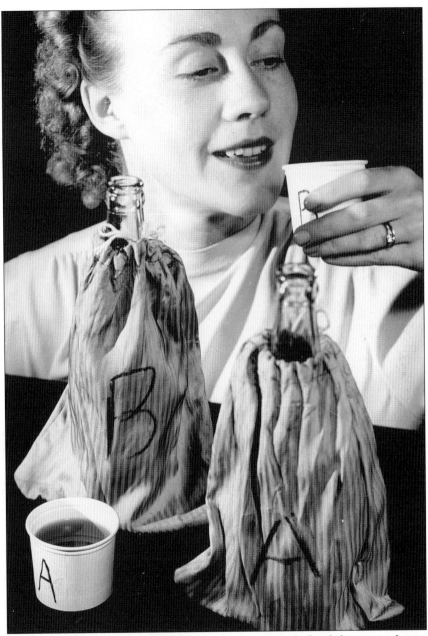

THE BATTLE OF THE COLAS, AUGUST 1940. Even back in 1940, the battle between colas was raging. Impartiality was maintained in this 1940 test by covering bottles with cloth bags. In the flavor tests, the colas were chilled, and samples were identified by a code letter only. The drinks were served two at a time to 29 tasters. Each tester was requested to state which sample he or she liked better and to rate both as good, fair, or poor. Each pair of samples was served twice to each taster—the code numbers were changed between samplings. The article concluded that most people could not detect any important difference between the five colas tested except for Pepsi-Cola, which rated higher for sweetness. And while the test did not include a caffeine analysis, the article included the following note: "Cola beverages should not be given to children and should be avoided by adults who get ill effects from caffeine."

FROZEN ORANGE JUICE, JANUARY 1950. To gather a representational sample for this test, shoppers in nine different cities were asked to purchase frozen orange juice. They were given insulated hampers with dry ice to store the orange juice for shipping, which would prevent deterioration prior to testing. Samples remained frozen between the time of purchase and the time of the tests.

FROZEN ORANGE JUICE, JANUARY 1950. To help consumers make informed choices, technicians who were analyzing the juice purchased for this test found that adding 18 ounces of water to the concentrate produced about as much liquid as manually juicing four pounds of oranges.

FROZEN CONCENTRATED FRUIT JUICES, OCTOBER 1951. The tests in this report included 27 brands of orange juice, 8 of grapefruit juice, 10 of mixed orange and grapefruit juice, and 2 of tangerine juice. Of the 27 brands, five were found to be substandard and received a rating of not acceptable. The complaints ranged from the inclusion of rind or seeds in the juice to bad and even rotten flavors. In the picture to the right, the vitamin C content of the juices is determined by means of a titration test that was performed on the samples.

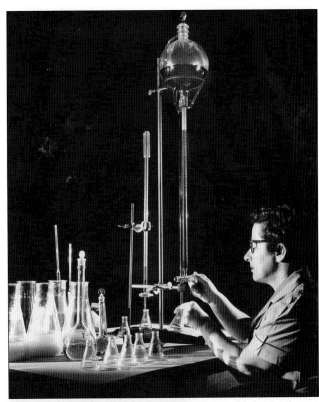

SOLD SHORT, FEBRUARY 2000. In an article on how products often contain less than they claim, *Consumer Reports* staff found a number of instances where consumers were misled. Coffee cans whose contents have diminished over the years were cited as an example of ways manufacturers hide price increases; they shrink the contents, but the price and container stay the same. In this photograph, a scientist drains and weighs canned peaches for fruit versus liquid content.

43

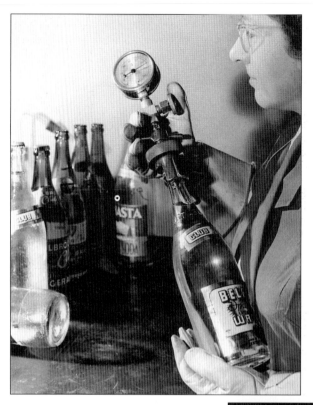

CLUB SODA, JULY 1944. Testing for the degree of carbonation (initial and retained) was done by means of a special gauge inserted through the bottle cap. Twenty-three brands were tested for their degree of carbonation as well as their color, odor, flavor, sediment content, and clarity. Technicians found considerable variance among available brands and judged three to be not acceptable because of low carbonation levels.

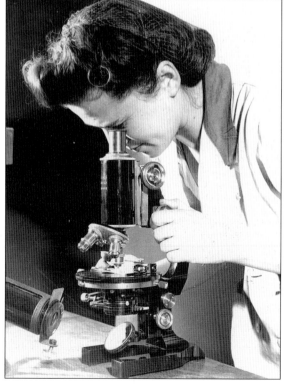

CHOCOLATE DRINKS, AUGUST 1945. With the reopening of shipping lanes from Africa that were closed during the war, chocolate products were again available on American store shelves. In this picture, samples are examined under a microscope for the presence of cocoa shell. The presence of too much shell rendered the beverage gritty.

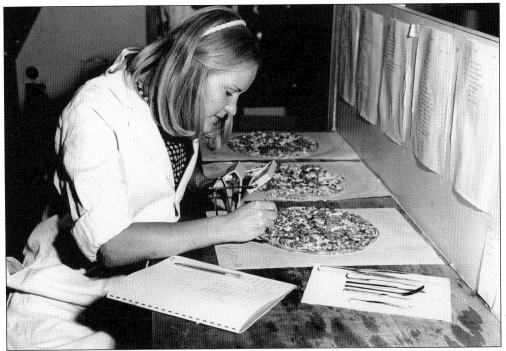

FROZEN PIZZA, JUNE 1972. A laboratory technician painstakingly removed meat and other ingredients from frozen pizza for weighing and then recorded the results in a laboratory notebook. Testers were disappointed overall with the taste of the frozen product. Additional complaints ranged from soft and soggy crusts to the presence of fecal bacteria.

WHAT'S INSIDE FROZEN POT PIES, AUGUST 1975. In addition to giving its own recipe for an "excellent" homemade pot pie, *Consumer Reports* found that many of the pies tasted bland, watery, and artificial and contained few vegetables. After the removal of gravy and crust, tests showed that less than 20 percent of the typical eight-ounce pie was composed of meat and vegetables.

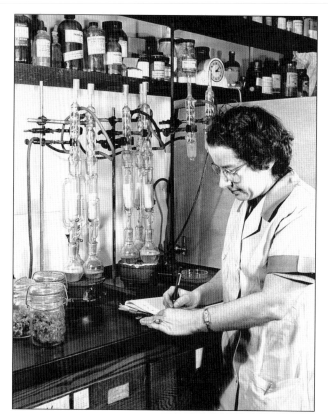

MEATS IN THE CAN, JULY 1948. The Soxhlet continuous fat-extracting apparatus was used to determine the percentage of fat contained in each canned meat brand. *Consumer Reports* recommended using fresh meat rather than canned hamburger and beef with gravy, stating that the canned products were not only more expensive but also less appetizing.

IS OUR FISH FIT TO EAT, FEBRUARY 1992. In this report, the result of a six-month investigation of canned fish, fresh fish, and shellfish raised serious questions about the quality of store-bought seafood, citing factors such as time lapses of up to 15 days for the fish to get to market.

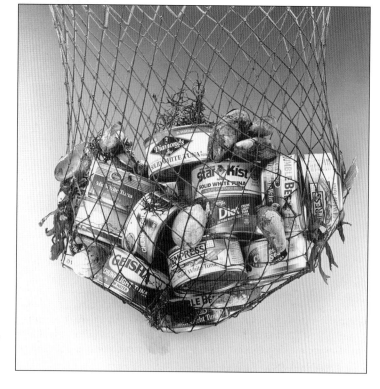

BAKING POWDER, JANUARY 1956. For this article, testers determined the volume of carbon dioxide produced by a given weight of baking powder. All the brands exceeded federal requirements and all were recommended. The report noted that despite the popularity of prepared cake mixes since 1950, a preliminary survey of the baking powder market showed no appreciable drop-off in sales. Evidently, the report concluded, many bakers still enjoyed making their cakes from scratch.

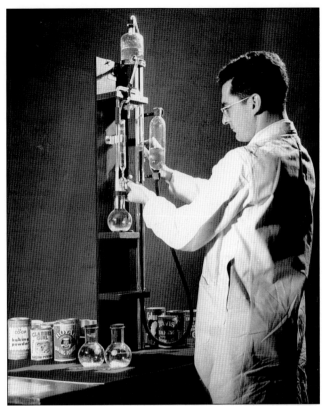

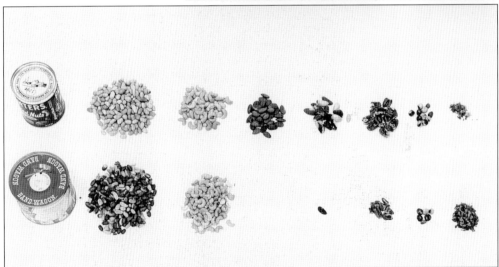

MIXED NUTS, NOVEMBER 1964. The first line of this report warned consumers that if they were planning to serve ready-mixed nuts to guests at holiday parties, they should make sure that their guests were particularly fond of peanuts and cashews. As demonstrated in this photograph, peanuts made up about one-half to three-fourths of the contents of these two cans. Cashews came second, followed by the more expensive nuts (almonds, Brazil nuts, pecans, and filberts), which were missing or very sparse in the bottom sample. The last pile consisted mainly of skins, salt, and fragments.

WORK COUNTER SURFACES, MARCH 1958. In this test, *Consumer Reports* recommended a rigid laminated plastic such as Formica or ceramic tile as the best surface for kitchen counters. The stain resistant properties of the counter materials were tested using 33 different substances, including ink, lemon juice, vinegar, beet juice, mustard, shoe polish, iodine, and ammonia.

HOW TO CHOOSE KITCHEN KNIVES, AUGUST 1993. In this report, knives were assessed on a number of factors, including comfort and balance. *Consumer Reports* recommended handling knives before buying them and even requesting that stores remove packaging to allow consumers to check the products. Testers found that several Hoffritz and Regent brand knives had badly fitted handles, raising concerns about food and bacteria gathering in the gaps.

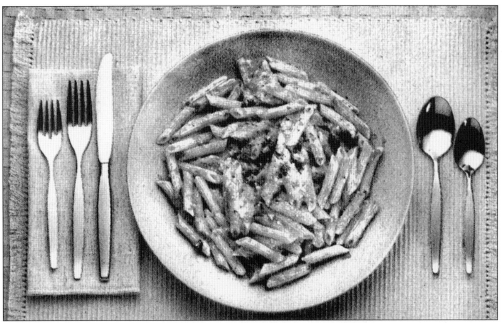

CUT THE FAT, JANUARY 2004. Portion size was included as an important issue in this report on the nation's weight problem. The pasta plate above (bought at a restaurant) totaled four cups, or eight times the size of what the U.S. Department of Agriculture's food pyramid considered to be the size of one pasta serving. The plate below shows one serving according to the same guidelines.

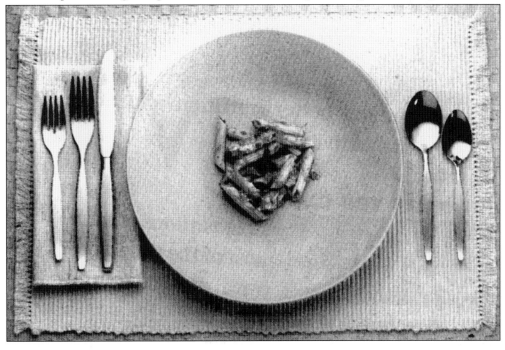

STRONTIUM-90 IN THE TOTAL DIET, OCTOBER 1961. A series of studies and articles preceded this report where *Consumer Reports* followed up on the question about Strontium-90 in the American diet. The photographs show one of many home economists in 25 cities preparing a typical meal.

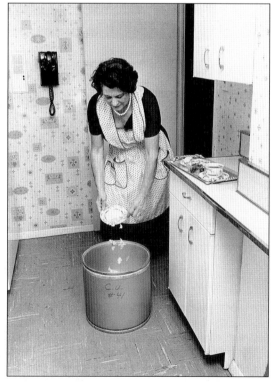

STRONTIUM-90, OCTOBER 1961. Groceries were bought at local markets, cooked in local water, and the inedible parts (such as bones, eggshells, and so forth) were removed. Food was collected for a period of two weeks and then shipped in special drums designed to preserve the food to *Consumer Reports'* consulting radiological laboratories to test for the presence of Strontium-90.

PLASTIC DISHES, JANUARY 1951. In these two photographs from a test of reusable dishes (not disposable plastic dishes), a tester shows her surprise at a melted cup. After spending five minutes in boiling water—necessary for sterilization, the report stated—the cup became deformed and unusable.

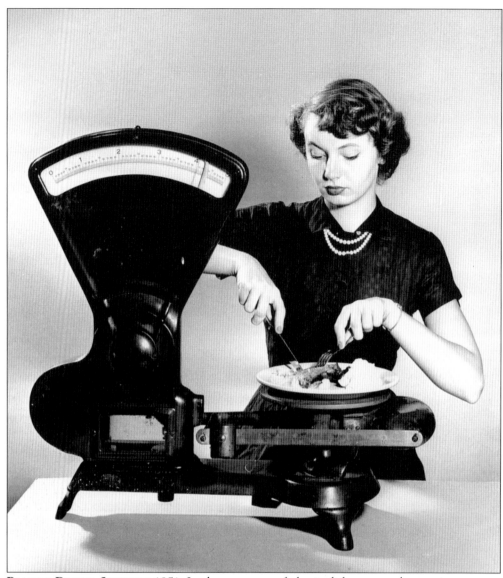

PLASTIC DISHES, JANUARY 1951. In the same test of plastic dishes as on the previous page, a scale was used to assess how hard different people would have to push with a knife to cut meat. The force exerted varied from three to five pounds (for tough meat). Testers used the average (four pounds) to test the reusable plastic dishes for scratch resistance.

Four

GETTING IT CLEAN

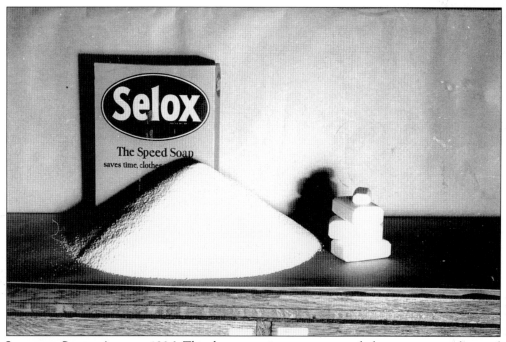

LAUNDRY SOAPS, AUGUST 1936. This demonstration was meant to help consumers understand that what appeared to be true was not necessarily the case. This photograph shows that a particular box of laundry detergent contained the equivalent of just a little more than three bars of soap. The report from which this photograph was taken opened with a quote from an advertisement of the day ("Are you unpopular?") that linked popularity to cleanliness.

WASHING MACHINES, AUGUST 1958. A technician carefully measured out a specific amount of laundry detergent to ensure that every machine received the same amount. The same attention was given to the pieces of cloth that were soiled and used to test the cleaning abilities of each washer. During the testing, machines performed up to 600 washes (or the equivalent of one to two years of actual usage). Many broke down during the tests and all were disassembled and examined at the end of the testing period.

THE DIRT ON DETERGENTS, FEBRUARY 2000. More than 4,000 swatches of cotton broadcloth were soiled with grass, grape juice, tea, coffee, chocolate milk, mud, tomato sauce, black ballpoint pen ink, ring-around-the-collar soil, old motor oil, and makeup. The swatches were washed under controlled conditions and then dried on a clothesline. The results from the test found that there were a few very good detergents, a long list of good ones, and a few mediocre performers.

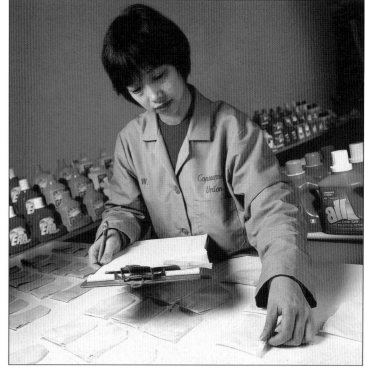

PLASTIC STARCHES, MAY 1950.
Synthetic starches appeared in 1948
and were first tested by *Consumer
Reports* in June 1949. The tests at that
time revealed that these products (only
two were available) could extend the
life of fabrics and were recommended
as a worthwhile addition to the laundry
shelf. This picture, taken on the roof
of the building that housed *Consumer
Reports'* testing laboratories at the
time, shows the samples that were used
during testing.

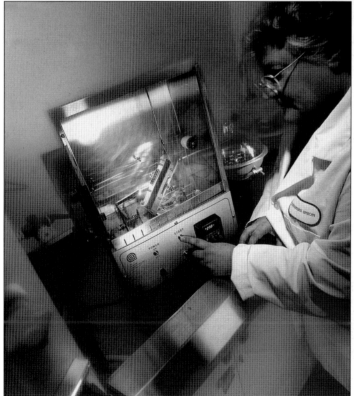

**FABRIC SOFTENERS
AND FLAMMABILITY,
AUGUST 2000.** In
this article, *Consumer
Reports* raised serious
concerns about the
flammability of fabrics
laundered with liquid
fabric softeners. In tests,
certain fabrics burned
considerably faster after
being laundered with
the product—taking
just under two seconds
to burn a five-inch hole
through the material and
exceeding legal limits.
The fabrics, tested in
the same conditions but
without liquid fabric
softeners, burned in
13 seconds—within legal
limits. In contrast, testers
found that fabric softener
sheets had little effect
on flammability.

FLOOR WAXES, FEBRUARY 1959. All staff members walking down this hall were enlisted to help test 21 brands of self-polishing wax, which were selected for this project by shoppers in 16 cities on the basis of national distribution. The report noted that while all the tests had been carried out on linoleum, an increasing number of homes and apartments were being fitted with other floor coverings such as asphalt or vinyl tiles.

SELF-POLISHING FLOOR WAXES, SEPTEMBER 1955. In this test, floor waxes were tested with a stream of falling sand. The weight of the sand required to wear away all of the wax was used as a measure of the wax's resistance to abrasion. The panel on the right (note the spot on the panel's lower left corner) had already been tested using this method.

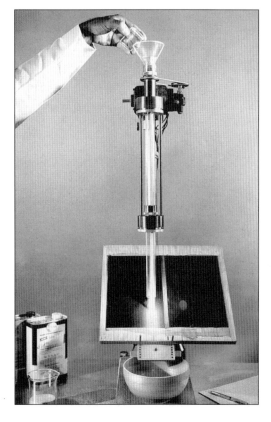

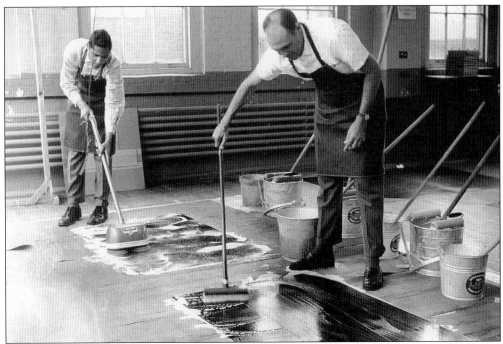

WAX REMOVERS, MAY 1959. Two images from this report demonstrate the variety of tests performed in *Consumer Reports'* laboratories. In the image above, linoleum strips are scrubbed clean with soap and water by technicians before the wax is applied. In another part of the testing process (below), pieces of linoleum and asphalt tile are immersed overnight in remover solutions to check for possible damage.

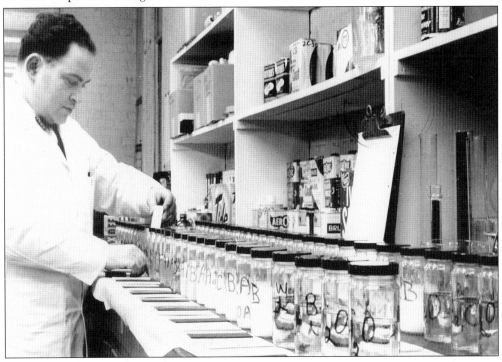

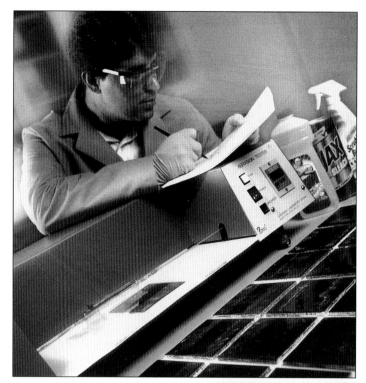

LIVING CLEAN, JULY 2000. In this picture, a mechanical scrubber is set up to test 41 different cleaning products on a variety of surfaces—for example, lard baked onto glass and grape juice and ketchup left on unglazed tiles. While testers came to the conclusion that not one product did everything well, the article raised the question of how many cleaning substances were needed to keep a house clean.

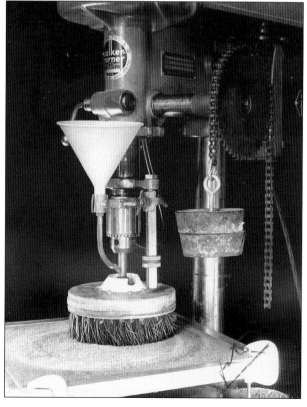

RUG CLEANERS, MARCH 1953. In a picture not dissimilar to the one above but taken almost 50 years earlier, a rug is cleaned using an impressive brush and mechanical device. The tube leading from the funnel fed solution to the revolving brush, and a standardized amount of dirt was brushed into the sample to ensure consistency from one sample to another.

UPHOLSTERY CLEANERS, MARCH 1953. These squares of cotton brocade were used to test various upholstery cleaners. The swatches show considerable differences in results ranging from good to only fair. Many of the cleaners used on carpets were also tested on upholstery fabric. The article recommended that colorfastness be tested and that consumers be aware that many upholstery fabrics are made of cotton, which can shrink when water is used as part of the cleaning process.

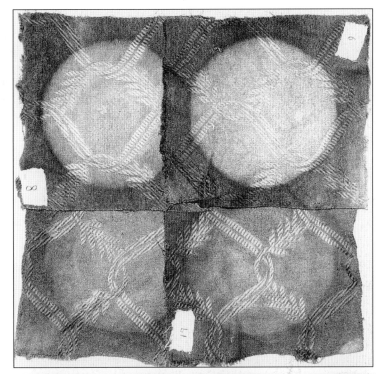

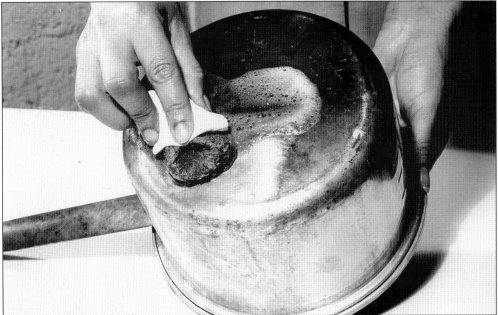

METAL POLISHES, APRIL 1951. In this test, *Consumer Reports* emphasized the importance of picking the right kind of polish for each type of metal and that the essential ingredient of a good metal polish—elbow grease—could not be found in a can. Of the 25 polishes that were tested, 5 were rated not acceptable because of flammability. Further testing demonstrated that even without the fire hazard, these flammable polishes rated at the bottom of the list. In the above picture, a tester demonstrates the effectiveness of soaped steel wool and elbow grease.

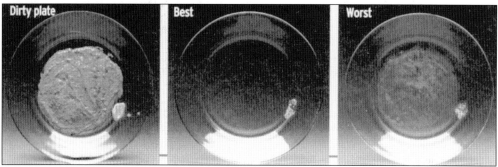

DISH DETERGENTS GET TOUGH, MAY 2001. Because of the presence of chemicals in many products, safety concerns have always been important for technicians and engineers. In this project, detergents were tested on glass plates that had been soiled with tough-to-clean foods. In the center, a top-rated product removed all but a bit of egg yolk. Detergents that rated poorly, as the one used to clean the plate on the right, tended to leave a visible coating of food.

DISHWASHER DETERGENTS, DECEMBER 1959. Dishwashers were relatively new in 1959 when this test was conducted. In fact, the article stated that less than a dozen brands of dishwasher detergents were available nationwide. Of the five brands tested, *Consumer Reports* staff noted that certain detergents were harsher on dishes with over-glaze decoration. The picture above shows the results of the worst and the best performers from the five samples.

OVEN CLEANERS, OCTOBER 1980. In this test, *Consumer Reports* warned of the highly toxic nature of oven cleaners. Of the dozen products tested, only one was recommended because of its nontoxic nature and overall performance. While other products performed the cleaning process very well, they were not recommended due to concerns about fumes and about damaging nearby surfaces because of harsh chemicals.

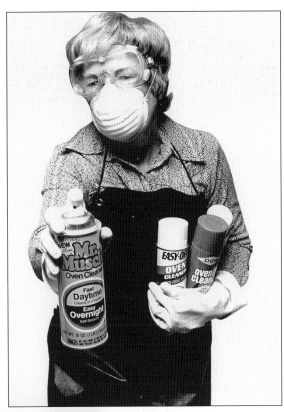

DRAIN CLEANERS, AUGUST 1970. In a report of 18 drain cleaners, technicians used glass drainpipes in the laboratory as a method of viewing precisely what happened when a drain cleaner met a blockage. Because of the highly toxic nature of drain cleaners, testers judged that while certain products made it very clear that the contents were poisonous, the labeling on others was not acceptable.

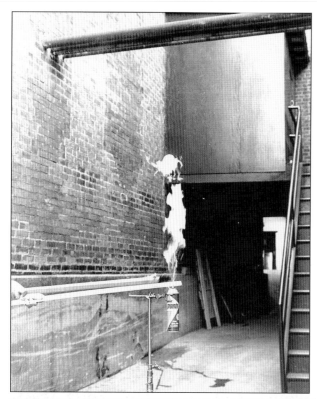

SELF-POLISHING FLOOR WAXES, OCTOBER 1969. In a troubling test, technicians found that the aerosol container of one brand that was intended to be used upside down emitted an easily ignitable gas when operated upright. The label did not include any warning of such a hazard, which could have led to a dangerous situation if a consumer had waxed a kitchen floor with a lit gas oven nearby.

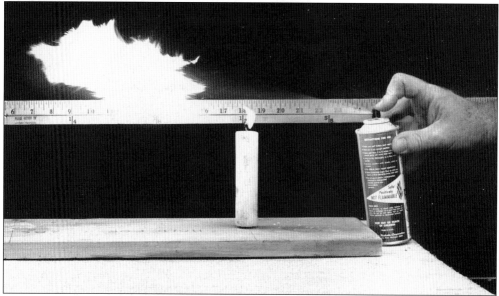

SPOT REMOVERS, JANUARY 1968. Of the 28 spot removers tested in 1968, more than half were judged unnecessarily hazardous for home use—even the acceptable cleaners required some prudence. The report included extensive information on federal labeling requirements for flammable substances. In the above picture from this test, a product is clearly marked "positively not flammable," but when assessed in a standard candle test, the product failed to live up to its own labeling.

Five

OUTDOOR LIVING

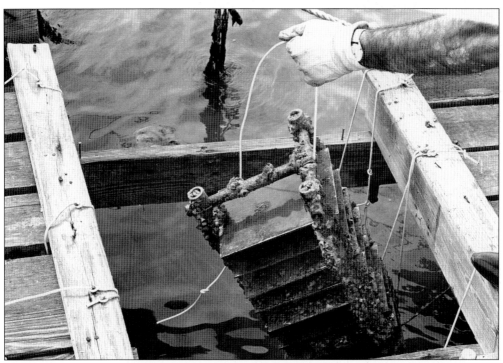

ANTIFOULING BOAT PAINTS, APRIL 1969. *Consumer Reports* tested 30 paint formulations intended to keep substances such as barnacles and algae off of boat hulls and found dramatic differences in performance. Aluminum-, wood- and fiberglass-painted panels were suspended from a floating dock in waters off Miami Beach for eight months. The image above shows panels that performed poorly (bottom of rack), while the top panel in the photograph performed much better than others.

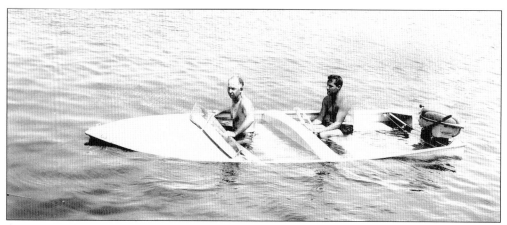

ALUMINUM BOATS, JUNE 1956. It was a good year for aluminum boats in 1956. All 12 models tested, including the one pictured here, performed well during buoyancy testing. Ten of the models incorporated Styrofoam compartments while two others used air tanks to ensure they kept afloat.

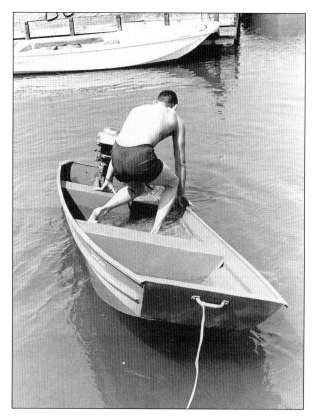

SMALL FISHING BOATS, JULY 1971. In testing 11 models of small fishing boats, *Consumer Reports* stated that these crafts belonged on quiet lakes and rivers or well-protected bays as they were all prone to being "tippy." The boats also reacted strongly to movement by passengers and in short, the report added, it would take very little to tip one of these boats or to fill it with water.

TENT HEATERS, SEPTEMBER 1969.
This report warned that when starting
alcohol and gasoline flame-less heaters,
it was necessary to ignite the units
outside of tents as the flame could
leap one to three feet high during the
lighting process. These heaters required
priming, which essentially involved
soaking the entire heating element in
gasoline or other camping fuel.

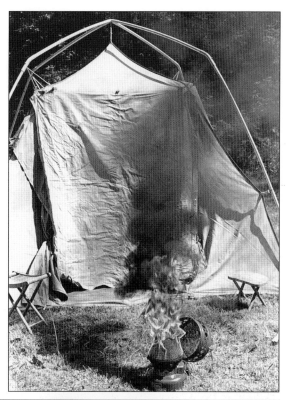

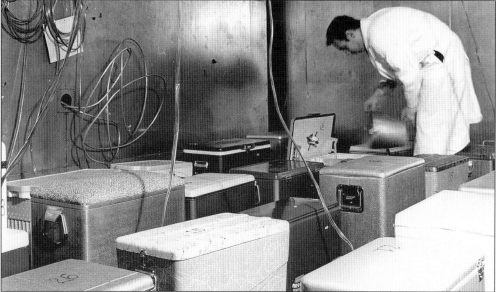

COOLER CHESTS, MAY 1962. Temperature sensors, also used in refrigerator testing, were placed
inside chests to help determine cold-retention ability. The report found that a higher price did
not necessarily mean better quality. In fact, the five top-rated chests fell roughly in the mid-price
range. They combined very good cold retention, high capacity (one and a half cubic feet or
more), and additional useful features such as hinged (rather than removable) lids and drains for
getting rid of water from melted ice.

VACUUM BOTTLES AND INSULATED JUGS, JULY 1951. For a report on 36 models of vacuum bottles and 27 models of insulated jugs, tests were conducted to check for the products' ability to keep liquid cold or hot. Jugs such as the one pictured here, which poured from a large mouth at the top rather than from a spout or a faucet on the side near the bottom, were judged to be difficult to use.

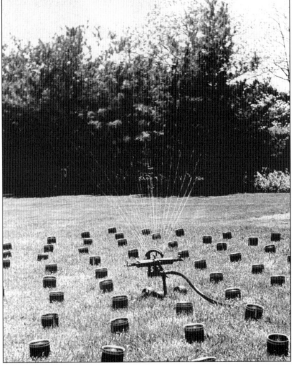

LAWN SPRINKLERS, JUNE 1952. In a test of 52 sprinklers, which included stationary and traveling models, the uniformity of watering and coverage was listed as an important factor influencing a purchasing decision. To assess each sprinkler, technicians laid out a pattern of metal cans to catch and measure the water where it fell. The pressure of the water used was controlled to ensure that sprinklers were tested under the same conditions.

PLASTIC AND RUBBER GARDEN HOSES, JUNE 1961. Engineers began their tests for this project by stretching out each new hose and measuring its water-flow rate under constant pressure. Most rubber models gave slightly lower rates of water delivery than plastic models gave.

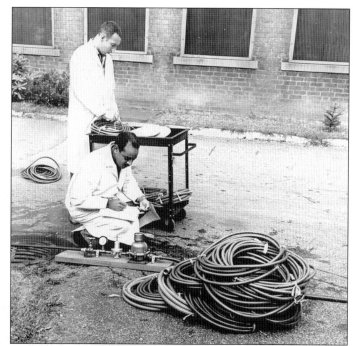

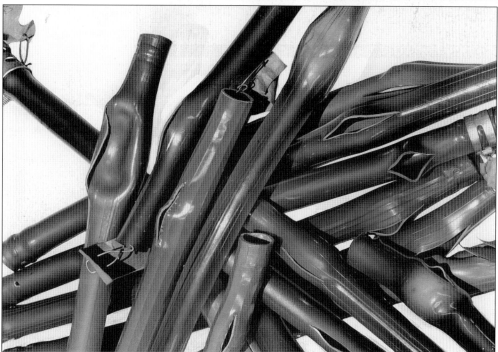

PLASTIC AND RUBBER GARDEN HOSES, JUNE 1961. As part of the same project, another test was performed before and after weathering the samples. Hose samples (maintained first at 32 and then at 130 degrees Fahrenheit by immersion in a bath) were subjected, in sequence, to pressures of 60, 80, and 100 pounds per square inch. None of the models without cord reinforcement passed the hot-water phase of this test. The above picture shows some of the typical failures.

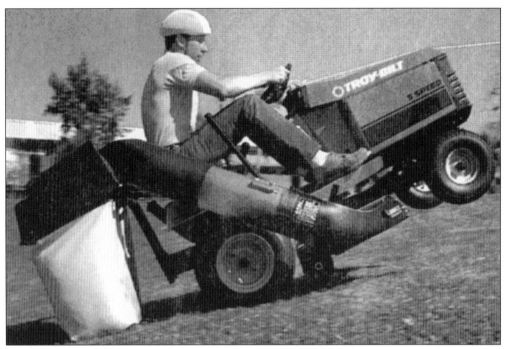

MOWERS FOR A BIG LAWN, JUNE 1993. A tester was surprised when, after letting out the clutch abruptly, the lawn tractor he was testing reared up. The report noted that this kind of problem was more likely to occur on a hill with material filling the grass bags on the back. While raising awareness of such shortcomings, the report also listed several models that included a front weight to act as a counterbalance.

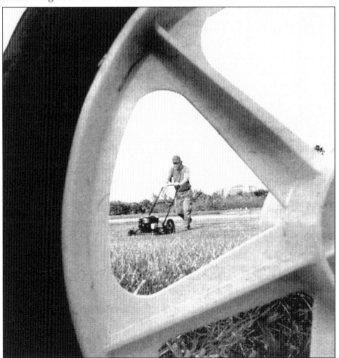

MAKING THE CUT, JUNE 2002. To provide information to consumers in time for spring and summer, *Consumer Reports* tests equipment like lawn mowers during the winter and early spring months in Florida. For this report on mowers, testers over-seeded a five-acre lawn in St. Petersburg with rye grass the previous fall. Mowers that left behind uncut grass, un-vacuumed clippings, or messy clumps received lower scores, as did mowers that were difficult to maneuver or that stalled in the grass.

GARDEN CARTS, OCTOBER 1973.
A test of garden carts revealed some rather unpleasant features of a few brands. The sharp center strut of certain models (including the one pictured here) could scrape ankles or even "stab users in the groin" when the contents of the cart were dumped out.

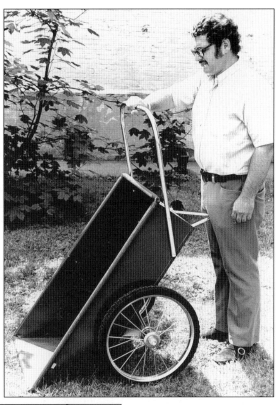

TENNIS BALLS, MAY 1965. As part of testing tennis balls for their bouncing properties, a technician carefully noted how high the ball bounced against a ruler mounted on a stand after the ball was dropped from a height of 100 inches. This test was repeated over and over with 29 different brands. The tests were conducted against standards set up by the United States Lawn Tennis Association.

ADD-ON BIKE SEATS FOR CHILDREN, JULY 1975. Most of the models in this 1975 test received a conditionally acceptable rating because foot guards were found to provide inadequate protection for children beyond the toddler age (children who were about 30 inches tall or more). The article recommended that homemade foot guards should be added to bicycles (the report included a how-to on building and attaching such a guard).

TRICYCLES, NOVEMBER 1960. This article gave consumers nine things to look for when buying a tricycle for their child including tire size, fenders, and rear platforms. Concerns were raised about a number of safety issues, including the relatively thin wheels and tires found on some low-priced models.

Six

TEXTILES AND SHOES

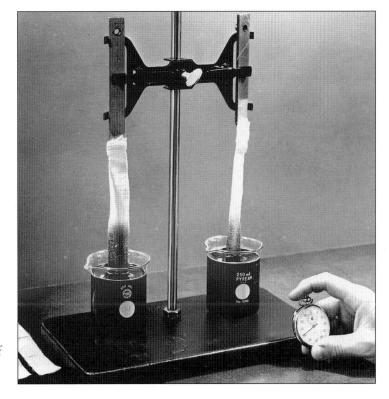

DIAPERS, AUGUST 1965. In this diaper test, the height to which colored liquid rose on fabric strips in a given time indicated the speed of a diaper's absorbency. All the samples tested here rated about the same. Testers also found that the newer fitted diapers, especially with snap fasteners, made diapering easier, but they usually held about half the liquid of other types of diapers (prefolded and flat).

LISLE AND RAYON STOCKINGS, JANUARY 1938. Lisle (made from cotton) was considered superior to rayon for both wear and appearance. Rayon, the article noted, was unsatisfactory in its present stage of development as it lacked elasticity. Stockings made of rayon did not have a very long life—often developing holes on the heels and toes very quickly. Prices for a pair of stockings at the time ranged from 39¢ for a low-quality rayon stocking to $1.25 for an imported brand.

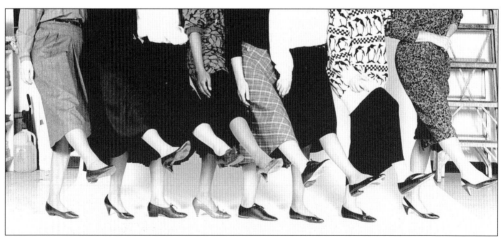

PANTY HOSE, BORN TO RUN, JANUARY 1987. This article stated that the number one complaint from women who bought panty hose (1.5 billion pairs were sold per year at the time) was that the products did not last long enough. Over 670 women were recruited to test 34 brands of panty hose—wearing them for a total of 250,000 hours. The top-rated products did in fact last a reasonable amount of time (8 to 10 days), while the others that rated lower failed in as little as two days.

MEN'S SOCKS, NOVEMBER 1952. The 62 brands tested for this report ranged in price from 39¢ to $1.50 a pair. Socks were laundered five times before being tested in order to shrink them to the size they would likely have for most of their useful life. After laundering, most socks conformed to their original size. The six styles that did not maintain the same size were rated not acceptable.

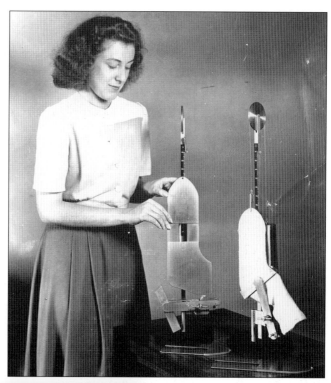

MEN'S SHIRTS, JANUARY 1953. This article stated that a man could still buy a good white broadcloth shirt for about $3. As part of the report, technicians evaluated durability through tests that measured the strength of the collar at the fold, conformance to marked size before and after several washings and, in the test depicted here, the tensile strength of strips of cloth that were cut from the sample shirts.

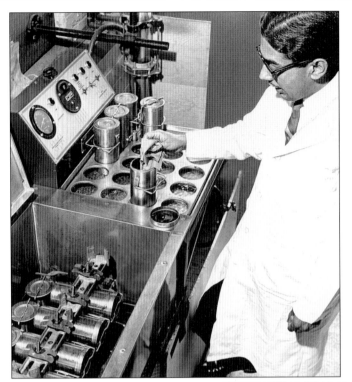

MEN'S RAINCOATS, MARCH 1970. This picture depicts how, under controlled conditions, multiple swatches of raincoat shell fabric were laundered and dry-cleaned to check for any resulting loss in water repellency and colorfastness.

MEN'S SUITS, OCTOBER 1950. The suits rated in this report cost between $37.50 and $165 but, the article stated, a good suit costing around $60 would give consumers the best overall deal. As part of the report, a standard test was performed to determine the fiber content of the cloth. In this picture, fabric is boiled in a special solution that dissolves wool but not cotton or rayon.

RAINCOATS FOR MEN, JUNE 1958.
Even when new, more than half of the
coats tested for this report performed
poorly for resistance to rain penetration.
This photograph shows a fabric sample
from one of the raincoats, which was
clamped to a blotter of known weight,
being subjected to a water spray of
controlled intensity. As part of the test,
a technician weighs a blotter to check
how much water had reached it through
the fabric sample. The photograph also
shows how intensity could be varied by
changing the height of the column of
water in the tall cylinder.

**RAIN, RAIN, GO AWAY,
MARCH 2001.** In this picture,
from a report on Gore-Tex
and other high-tech fabrics,
a technician performs a test
that looks very similar to the
1958 photograph above. In
this 2001 test, fabric samples
were cut from jackets and
backed with blotter paper.
Each sample was sprayed
with 500 millimeters of water
from a height of two feet.
The blotter paper was then
examined to see if any water
had penetrated the fabric.

BATH TOWELS, JUNE 1939. This article stated that a towel that tears is a nuisance and an expense. The article also noted that a towel that was expected to withstand numerous tugs and pulls should have a close weave and a firm texture. Among the 25 towels tested for this report, six were rated not acceptable for problems ranging from excessive shrinkage to edges that were cut instead of woven.

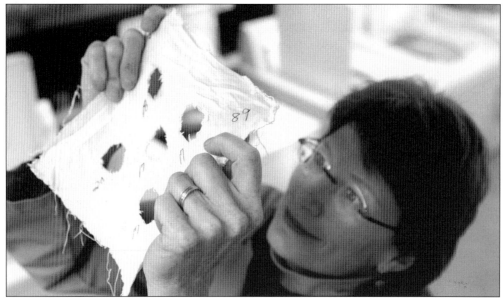

NEW TOUGHER TESTS, JUNE 2004. In response to innovations in the washing machine market, this article focused on changes that were being made to *Consumer Reports'* tests to better reflect the improvements of the machines. In the above photograph, an engineer examines a swatch of cloth to see which washers were the most gentle. As part of the new testing process, gentleness tests were made tougher to give consumers a better idea of how washing machines would treat their laundry.

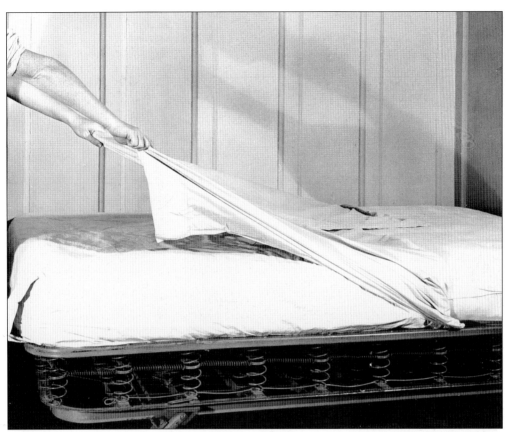

SHEETS AND PILLOWCASES, FEBRUARY 1952. The above picture, taken from a section of this 1952 article on the care of sheets and pillowcases, suggested loosening sheets from all around the mattress, rather than yanking them off the bed, in order to extend their life. The article also discussed a recent innovation in the bed linens market—sheets with prebuilt corners (fitted sheets). The image below, from the same test, shows sheet shrinkage. Compared to a piece of cloth cut to 108 inches, sheets advertised as 108 inches long could lose an average of seven inches due to shrinkage and another six inches due to hemming, a total loss of 13 inches.

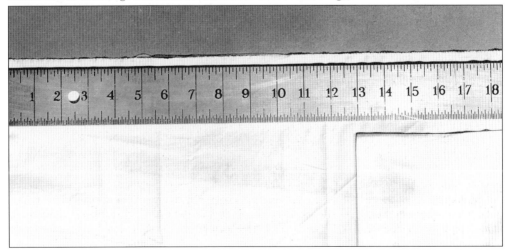

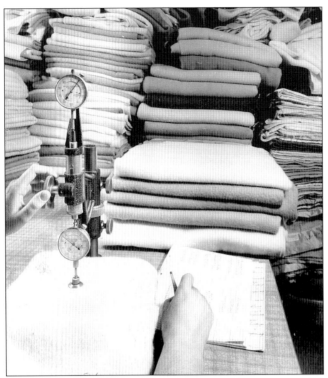

BLANKETS, SPECIAL FIBERS VERSUS WOOL, FEBRUARY 1958. To test blankets, a compressometer was used to measure blanket thickness and the height of the nap. Thickness, the report noted, was the major factor contributing to a blanket's warmth. Most blankets, the report added, achieved their warmth not by using a thick, heavy base fabric but by employing a relatively high nap of resilient fibers.

WASH-AND-HANG CURTAIN FABRICS, FEBRUARY 1960. A technician examines curtains for overall appearance in this 1960 test. Testers washed curtain panels a total of nine times, increasing the severity of the laundering process with each wash. The first three washes were done by hand, the second three according to manufacturer directives, and the last three using the wash-and-wear cycle on an automatic washing machine. The material Dacron was found to be the most satisfactory of all, but every sample tested required some degree of touch-up ironing.

Zippers, July 1972. A close-up of one of the tests for zippers was included in this article, which praised four manufacturers for their consistent high-quality products. The test pictured here demonstrated the force needed to pull a zipper apart. Durability and performance were also examined using a specially designed machine that opened and closed three samples of each model up to 10,000 times.

Shoes that Can Take a Hike, July 2001. In a report on hiking shoes, a panelist walked along a path of plastic climbing grips (used by indoor climbers) created in *Consumer Reports*' laboratories to test how the shoes would perform against jagged rocks and uneven terrain. The panelists recorded their observations while a technician monitored data from special sensor insoles placed inside each pair of shoes.

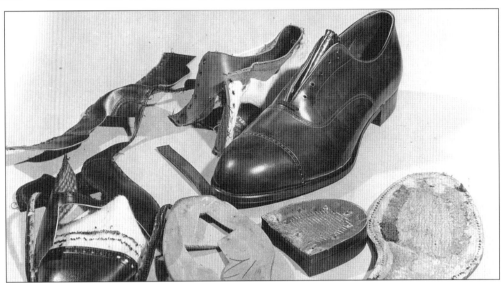

MEN'S AND WOMEN'S SHOES, SEPTEMBER 1936. Men's shoes were broken down into their component parts in this test of 13 brand-name shoes. The report found five brands not acceptable, with problems ranging from heels and heel bases made of one single piece of rubber that was painted to look like leather, to inferior uppers, to an unusually high-priced pair of shoes that had only average durability ($7.50, while most shoes were priced around $4 to $5).

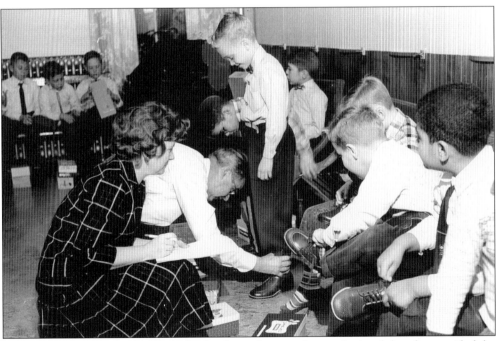

SHOES FOR BOYS, SEPTEMBER 1959. In the above photograph, a professional shoe fitter verified the fit of all the shoe samples worn by a test panel of 96 young boys. Each of the boys tested two different pairs of shoes and the testing lasted 15 weeks. The report stressed the importance of proper-fitting shoes for children and cited a 39-state study that found that more than half of primary school students and 79 percent of high school students examined had some kind of foot defect.

Seven

AUTOMOBILES AND ACCESSORIES

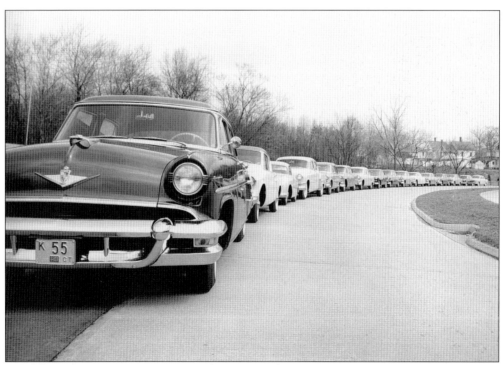

AUTOMOBILE RATINGS, MAY 1954. This picture shows some of the cars tested for the 1954 automobile issue. In the course of the tests, each car was driven an average of about 2,500 miles.

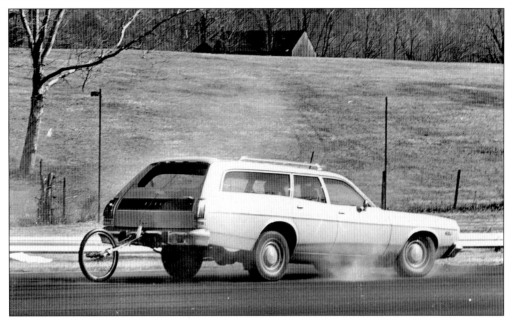

How Consumer Reports Tests Its Cars, April 1974. The 1974 automobile issue had the following quote: "You can read the ads. You can pore through the manufacturer's literature. The point of our automobile test program, and the reports that stem from it, is to help you tilt the odds in your favor." Above, a model was put through a breaking test to determine stopping distance, the range of pedal effort, and directional stability.

Five Intermediate V8s, February 1968. During road tests, the Pontiac Tempest bottomed its rear suspension and struck the road even when it was only lightly loaded. The ride consisted of almost continuous snappy, vertical motions. Fully loaded, the car cleared only two and a half inches off the ground—inadequate in the opinion of *Consumer Reports* and the lowest clearance on record (a 1966 Tempest had previously held that honor, clearing the ground at two and seven-tenths inches).

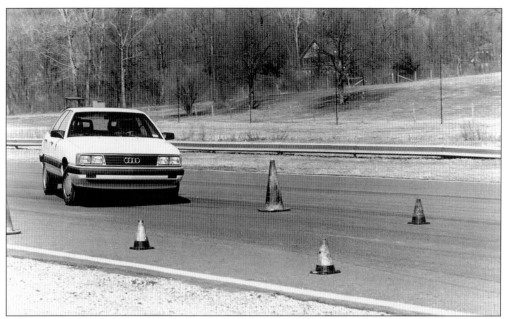

DOUBLE THE MONEY, DOUBLE THE CAR?, JULY 1984. *Consumer Reports* compared three European models to luxury American models. The report found that all four cars ranked among the best tested but added that price should be a consideration. The cars ranged in price from $17,968 to $25,966—considerably more than their Japanese counterparts ($10,000 to $12,000 at the time, including import taxes).

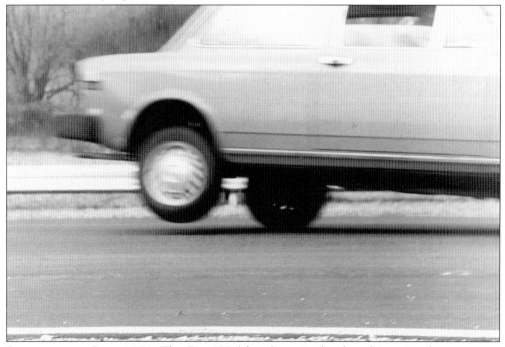

SUBCOMPACTS, JUNE 1974. The Fiat 128 (above) received only a fair rating for emergency handling. In the avoidance maneuver, and in very hard turns around the test track, the inside rear wheel lifted off the pavement, making the car feel unstable.

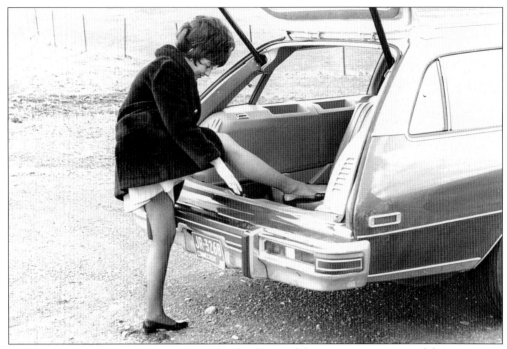

INTERMEDIATE WAGONS, MAY 1974. The third seat of this station wagon rated fair to poor in terms of comfort for two adults. Leg room was inadequate and the seat facing backwards could make some passengers queasy. Of the models tested, access to the back seat in this model was judged worst of all. The liftgate was very wide, and the bumper had no step to help a passenger get into the vehicle.

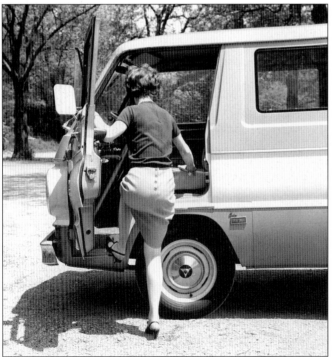

ROAD TESTS OF FAMILY BUS-WAGONS, JULY 1966. The vehicles tested for this report all had high, narrow front steps that were described as awkward and should not be attempted by anyone who was not reasonably agile. Since there was no engine or hood in the front of the vehicle, the report also noted that the driver and passenger were only separated from collisions by a large glass windshield, a light frame, and some sheet metal.

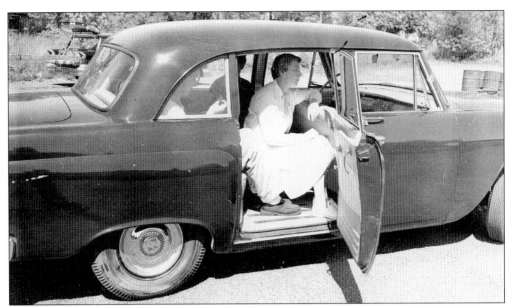

THE CHECKER CAB AS A FAMILY SEDAN, AUGUST 1957. In this report, the familiar cab was tested in its "civilian clothes" to judge its fit as a family sedan. Designed to be an economical and durable form of transportation without frivolity, the car turned out to ride and handle better than the average American sedan at the time. The article praised the knee room in the rear seat (26 inches), which was double that of the Imperial (a family sedan). The cab also allowed for the addition of two optional passenger seats (pictured below) at a cost of $29.70 for a pair. The basic cost for the vehicle was $2,374, which included automatic transmission.

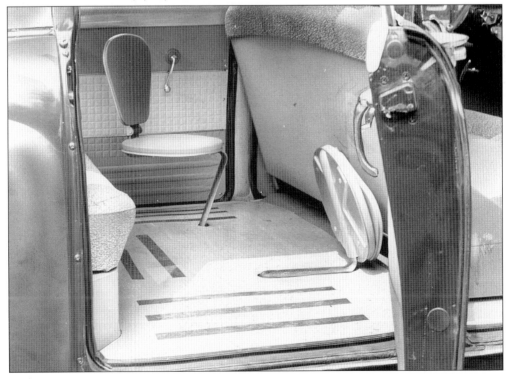

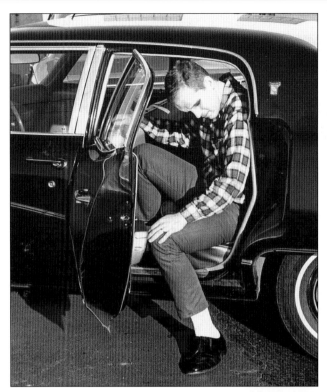

FIVE INTERMEDIATE V8S, FEBRUARY 1968. In the late 1960s, intermediates were about a foot shorter and four inches narrower than their full-sized counterparts. In addition to providing a poor ride and the worst handling of the five models tested (the article stated that the chassis and the passenger compartment often seemed to want to go their separate ways), the Buick Skylark proved to be quite difficult to exit.

MIDSIZE SIXES, MARCH 1974. A penalty of two miles per gallon was what consumers would have to give up if they selected one of these cars over a similarly equipped compact. A year earlier, this may not have been an issue, but in the midst of the energy crisis, every gallon of gas counted. Consumers would also give up headspace in the backseat of the Matador, which, the article stated, was nonexistent in the two-door version.

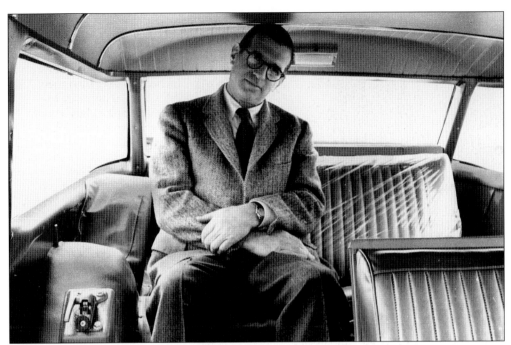

STATION WAGONS, JUNE 1960. *Consumer Reports* noted that as a result of the growing popularity of this type of car, one in five new vehicles introduced by manufacturers in recent years had been a station wagon. The report also referred to these vehicles as "six passenger." On closer look, the article noted, the wagon's third seat (especially a forward-facing one) could not seat an adult comfortably. The cushion was very thin, the ceiling hard, and the dome light sharp.

PASSENGER VANS ROAD TEST, FEBRUARY 1993. In reference to the third seat, this article noted that the Volkswagen's rear seat was by far the largest of the four vans tested. Three big adults could sprawl out comfortably on the seat with lots of head, shoulder, and leg room to spare. Unfortunately, the article also stated that the van's delivery-truck heritage made it unpleasant to drive.

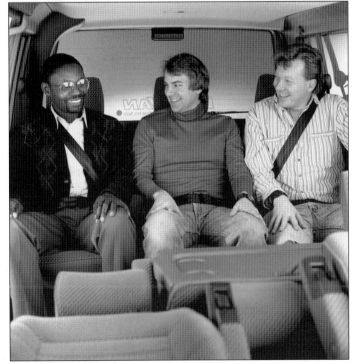

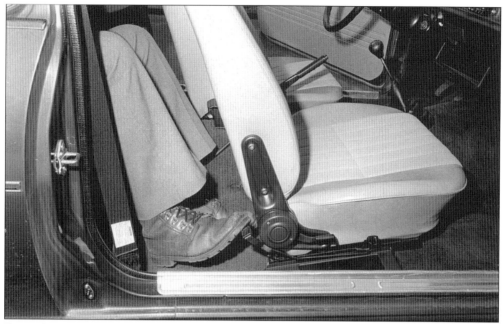

Four Subcompact Hatchbacks, May 1979. *Consumer Reports* noted that amid signs of tightening gas supplies, motorists were again flirting with smaller cars. In February 1979, domestic and imported subcompacts accounted for a full 34 percent of new car sales. Testers noted that the Mazda GLC included a convenient pedal that made it easy for a rear-seat passenger to release the front seat when exiting the vehicle.

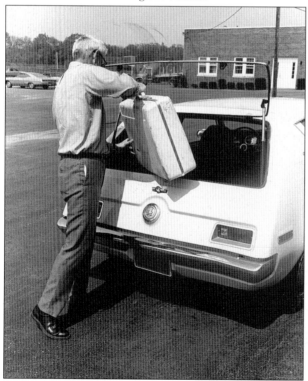

The AMC Gremlin, July 1970. The luggage compartment in the Gremlin did not impress *Consumer Reports* testers. While the spare tire took up much of the rear space, the article noted that the lack of a separate trunk meant that considerable noise intruded from the rear of the vehicle. Access to the rear was also problematic. The high-angled liftover made it difficult to load heavy cargo.

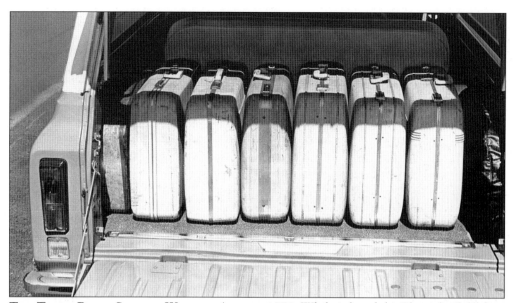

TWO TRUCK-BASED STATION WAGONS, AUGUST 1972. While it found the Chevrolet Suburban Carryall conditionally acceptable, this report did praise the vehicle for its ability to hold six large suitcases without blocking the driver's view. The vehicle received the conditional rating because, under certain conditions, there was a danger that deadly exhaust could leak into the passenger compartment.

ROAD TEST, FEBRUARY 1994. In a report on family sedans, testers looked at a variety of safety concerns including what the article called a "booby trap"—when the trunk lid was open it hung very low and it had sharp corners that could injure a motorist who was lifting cargo into the trunk.

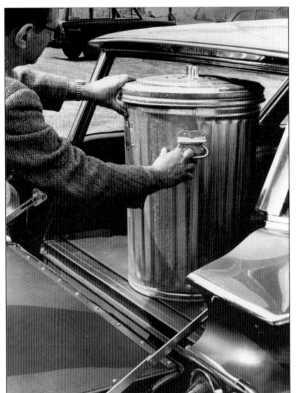

STATION WAGONS, JUNE 1960.
In this photograph, a tester unsuccessfully attempts to place a garbage can upright in the largest of the tested station wagon models, the Chevrolet Parkwood V8. Interestingly, the smallest model of station wagons tested in 1960 did accommodate the upright can demonstrating the advantages and disadvantages of design differences. At $3,202, the Parkwood did, however, receive a Best Buy mention.

ROAD TEST, MAY 1993.
While falling short on ride and comfort, testers did like the porthole feature on this Audi CS Quattro. The porthole in the trunk's bulkhead allowed for long, narrow cargo to fit in the trunk. A sleeve was included that unfurled inside the car to keep cargo, such as wet skis, away from rear-seat passengers.

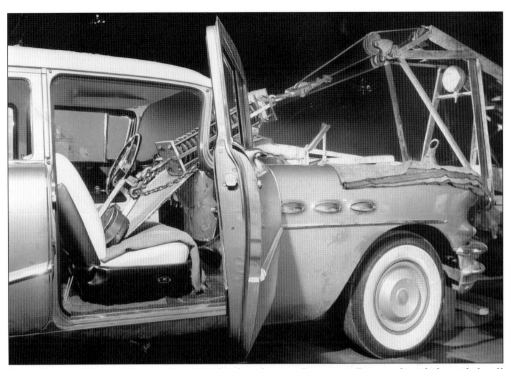

SEAT BELTS, MAY 1956. In this 1956 landmark test, *Consumer Reports* found that while all manufacturers were now offering seat belts, two-thirds of the 39 belts tested failed to meet minimum performance standards. The test depicted in the above picture was meant to simulate a car crash in which the belt was subjected to a 3,000-pound pull. The picture below shows some of the belts' failures, which included broken stitching, webbing failure at the door bracket, floor bracket ruptures, and broken buckles. Seat belts were not mandated in the front seats of cars until 1968.

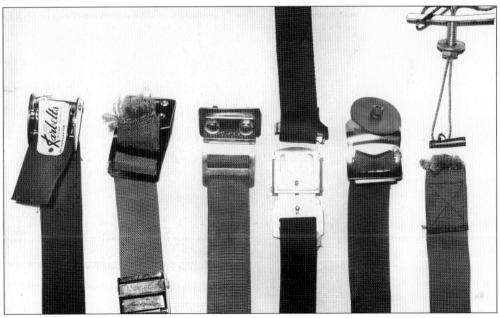

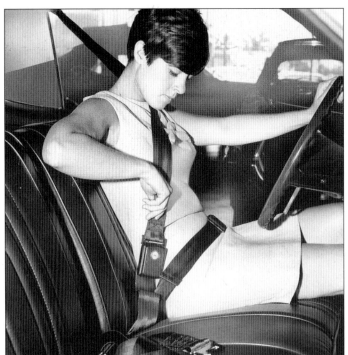

AUTOMOBILE SAFETY BELTS, OCTOBER 1968. In this article, *Consumer Reports* asked why the majority of Americans still disdained wearing safety belts. The magazine cited 1967 National Safety Council statistics, which claimed that seat belts had saved the lives of 2,000 people but that 8,000 to 10,000 had died as a result of a failure to buckle up. The report also provided tips on how to maximize safety through the proper use of seat belts, as shown here.

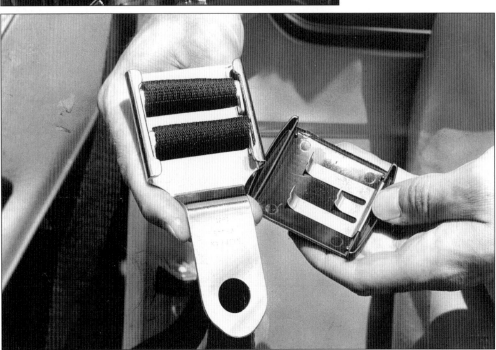

ECONOMY IMPORTS, OCTOBER 1968. In a report on small imported cars, *Consumer Reports* found that the Volkswagen's three-point lap-and-shoulder belt was convenient to use and adjust. After noticing that it loosened while in use, though, the magazine immediately contacted the manufacturer who repaired the deficiency with a small spring clip (pictured above), and a recall was issued.

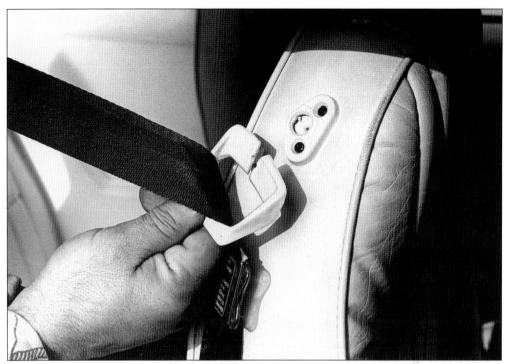

FOUR SUBCOMPACTS, JUNE 1977. Seat belts were still a concern in 1977 when testers found that this plastic guide, used to help position shoulder belts properly, broke off when the seatbacks were folded forward.

AUTOMOBILE SAFETY FOR CHILDREN, JUNE 1963. This picture shows one of the belts that was found not acceptable. During impact, stress was concentrated on the waist, which could cause the liver or spleen to rupture. Of the nine models tested, *Consumer Reports* found only one seat belt that provided maximum protection. In giving their rating, testers cited the combination chest and lap strap secured to a floor-anchored strap as their reason.

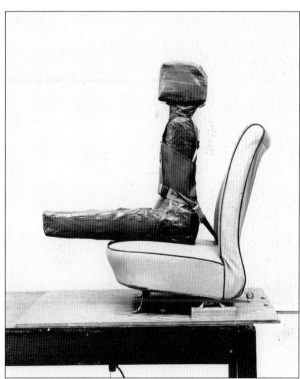

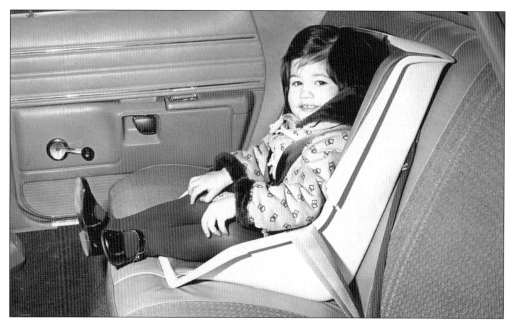

INFANT CARRIERS AND CHILD RESTRAINTS, MARCH 1975. *Consumer Reports* had complained in 1972 and again in 1974 that safety belt standards for children were inadequate. In this report, the magazine found that 5 of the 19 models tested were not acceptable. When tests were run using dummies, some of the problems found included seats that collapsed, excessive head travel, and extreme concentration of impact forces on the abdomen.

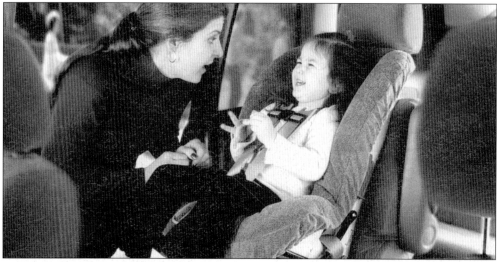

BEST CARS FOR KIDS, APRIL 2004. For this article, technicians tested vehicles judged best for kids, answered questions that indicated which vehicle was safest for families, and identified what vehicle was best for a teenage driver. Of the 39 vehicles in this report, *Consumer Reports* gave top honors to the Toyota Sienna, which received an excellent rating. The vehicle scored well because it included the most family-friendly features.

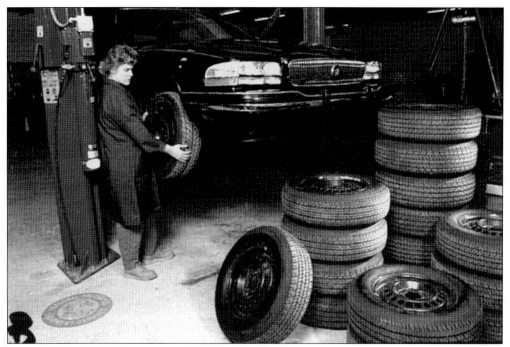

AUTOMOBILE TIRES, FEBRUARY 1993. The above photograph shows some of the 72 brands of tires that were mounted and removed during the testing for this report. In the picture below from the same report, a test driver secures an electronic device that measures speed and distance traveled. The device projects a light beam that scans the texture of the pavement.

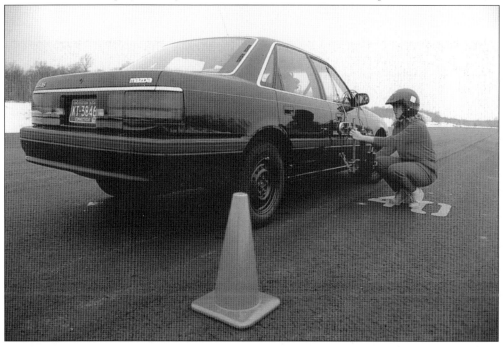

AUTOMOBILE TIRES, SEPTEMBER 1965. Having survived a 2,820-mile high-speed safety run against a steel wheel, the tire pictured above was measured for cross-sectional growth. The article from which this picture was taken raised serious concerns about the safety of tires and called for better standards. *Consumer Reports* noted that the 165 million tires manufactured and sold every year were produced by only 14 rubber companies and their subsidiaries and that these companies could wield immense power against anyone trying to regulate their industry.

AUTO-SERVICE JACKS, JUNE 1980. While stating that this inflatable jack was not an alternative to the hydraulic jacks included in the report, *Consumer Reports* found that this product was easy to attach and performed well. Testers abused the inflated bag by kicking it and jumping up and down inside the car, but the bag held. When intentionally punctured with a knife, the bag did not rupture explosively but deflated slowly.

ELEVEN TIRE GAUGES, FEBRUARY 1952. In researching this story, *Consumer Reports* staff checked the tire gauges available for public use at gas stations and found that 18 of the 20 gauges checked gave inaccurate readings. The proper use of a tire gauge, the article noted, can result in significantly increased tire life, offering the car owner savings worth many times the cost of the gauge. In fact, *Consumer Reports*' top pick cost only $1.39. This picture demonstrates how each tire gauge was checked on a pressure tank fitted with a calibrated master gauge.

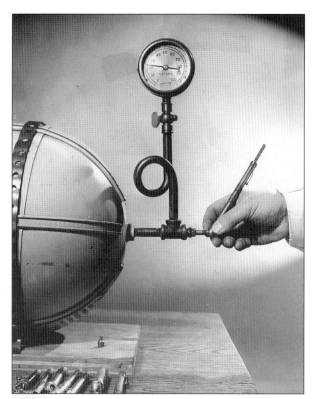

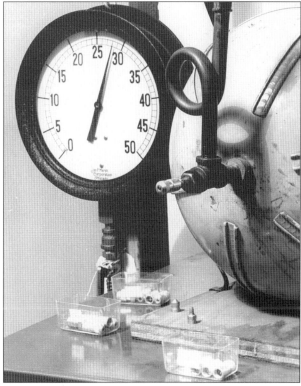

BUILT-IN SIGNALS ON TIRE-VALVE CAPS, SEPTEMBER 1958. *Consumer Reports* cancelled further testing of the No-Lo tire-pressure indicator, pictured here and attached to a pressurized tank, calling the device another good idea that had not yet been worked out. If the pressure was too high, a red plunger was supposed to pop out, while if the pressure was too low, the head of the cap would drop back in. The device did not work as advertised.

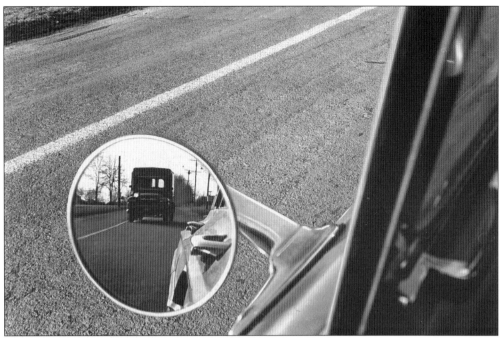

CONSULTANT'S CHOICE, APRIL 1964. In the annual April automobile issue, experts suggested some optional equipment that would be worth the cost. The experts recommended a padded instrument panel (dashboard), slip differential, adjustable steering wheel, individually adjustable front seats, and a rearview mirror on the driver's side (which would allow drivers to see advancing traffic in blind spots before changing lanes).

SAFETY IN THE 1967 CARS, JANUARY 1967. This report highlighted a few of the safety innovations added for the 1967 model year. All General Motors two-door cars would henceforth have latches to keep the front seats from flying forward. GM would also now use only soft-flattened plastic knobs on its window cranks and soft plastic for both coat hooks and inside rearview mirror brackets. The inside mirrors on all 1967 cars were also designed to either break away on impact or were positioned on pivots so that they would give way when struck.

HEADLIGHT TESTING, WHAT WE LOOK FOR, APRIL 2003. Vertical flat, black panels were placed at fixed distances to represent darkly clad pedestrians and hard-to-see objects. Both high- and low-beam performance were evaluated, but low-beam performance was stressed since most drivers rely on this setting. Tests were conducted on a moonless night in good weather conditions.

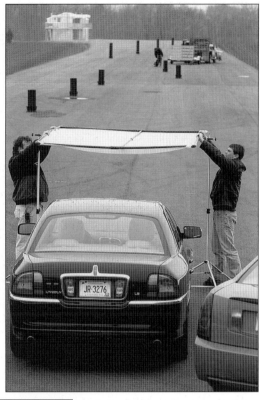

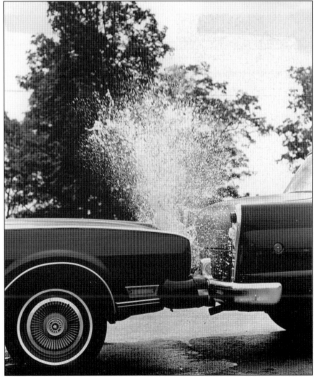

WATER BUMPERS FOR CARS, SEPTEMBER 1969. Designed to absorb impact as much as to meet it, this horizontal plastic tube was filled with water and projected about six inches farther than the original-equipment bumper it replaced. Comprised of quarter-inch walls attached to a plywood mounting plate, the product contained 24 quarts of water and could be filled along the top through holes. Sold for $185 per pair, testers concluded that, when tested at very low speeds against regular bumpers, the water bumpers reduced repair costs.

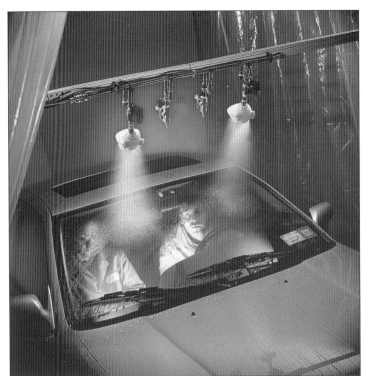

WATER, WATER EVERYWHERE, OCTOBER 2000. The windshield wipers of 140 cars were tested for this report. Two different blades were installed on every car and were used normally by the vehicles' owners. The technicians pictured here devised a laboratory test to assess cleaning performance in a drizzle and a downpour on both clean and dirty windshields. The blades were tested when new and then again after six months of use.

WAX TO THE MAX, MAY 2000. Certain car waxes and polishes can leave tiny scratches or haze. As part of the testing process, a project leader waxed individual panels with the 26 products included in the tests. The samples were then rated on the extent of hazing or scratching.

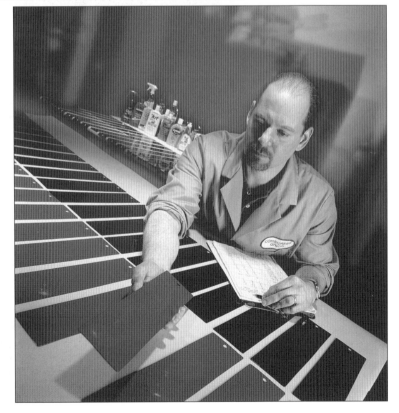

A New Record Player for Automobiles, April 1960. Record players had been available in certain cars since 1956 when the above pictured unit made its appearance on the scene. Able to accept 14 stacked records, the stylus did not skip in a moving car when tested at various speeds. Users were cautioned, however, that the stylus would wear records down faster than a normal record player because of the tracking force (needle pressure) needed to keep records on track. A later model tested in 1961 (right) was found to be less convenient than this model because it only accepted one record at a time (around four and a half minutes of music) and provided no space for storage.

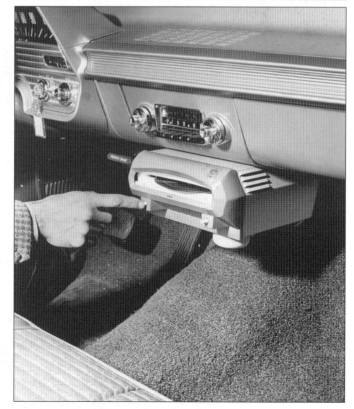

AUTOMOBILE VACUUM CLEANERS, APRIL 1968. Unfortunately, as this article stated, tests of one dozen automobile vacuum cleaners turned up only one model that did a good job. The Auto-Vac F-500, like most models, spilled sand if tilted after the power was cut off. Testers rated five models as not acceptable. The reasons ranged from sand particles passing through the external cloth dust bag to breakage in plastic housing caused by gravel that was thrown around by the impeller.

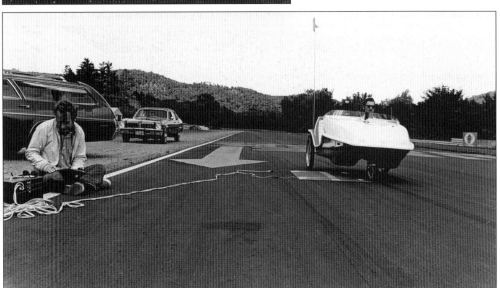

A PEDAL-POWERED VEHICLE, OCTOBER 1973. Testers suggested waiting for a pedal-powered car that had four wheels for stability when this vehicle was put to the test in 1975. The gasoline shortage of the early 1970s spawned an interest in such vehicles. This model, intended for resorts, retirement villages, and college campuses cost $379 and weighed 135 pounds. Complaints about the design included braking problems on hills, the vehicle's width—it was too wide to ride safely in bicycle lanes—and the maximum speed of 10 miles per hour.

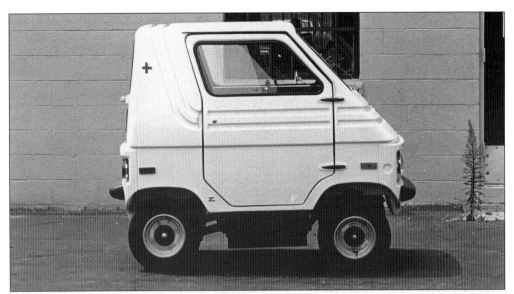

ELECTRIC CARS, OCTOBER 1975. *Consumer Reports* found these two electric cars clearly unsuitable for any normal transportation function. How well these cars performed depended very much on outdoor temperatures. For example, in summer weather, the range of one of the vehicles was about 20 miles but when the temperature dropped to 40 degrees, the batteries needed to be recharged after less than 10 miles. A full charge usually took more than eight hours. Batteries also drained relatively quickly when the car was running at top speed (around 30 miles per hour) or over hilly terrain. After half the charge of the batteries had been used, the headlights dimmed to about half their intensity, making night travel a problem. The cars' handling and controls also proved to be problematic. They cost around $3,000 each.

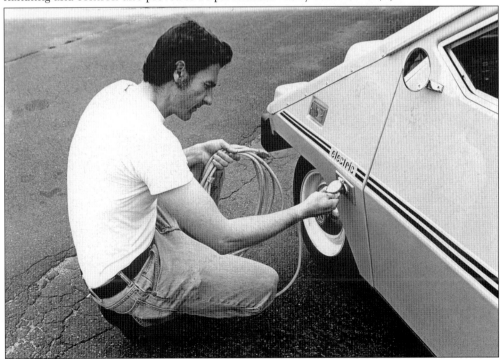

FIFTIETH ANNIVERSARY AUTOMOBILE ISSUE, APRIL 2003. In 2003, *Consumer Reports* celebrated the publication of its 50th automobile issue. In the introduction to this issue, Consumers Union president Jim Guest wrote, "In 1953, the automobile was a far less sophisticated machine than it is today. But one thing has remained the same throughout the past 50 years. As *Consumer Reports* editors observed in the May 1953 issue: 'there is no denying the overriding importance of the automobile in this country's life, nor the steady interest, sometimes verging on idolatry, with which millions of American consumers regard their own or their neighbor's or the automobile dealer's models.'"

Eight

ELECTRONICS

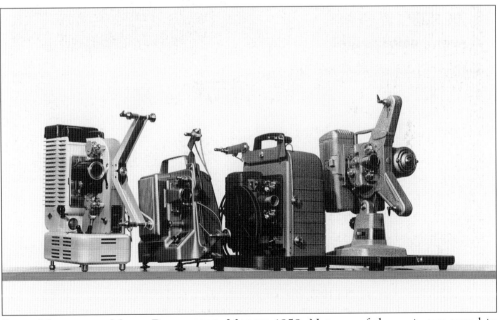

EIGHT-MILLIMETER MOVIE PROJECTORS, MARCH 1958. Not one of the projectors tested in this report could display a completely sharp picture. Of the 19 models, testers found only 10 acceptable. One model, the Mansfield Holiday, rated poorly on almost all accounts, and film projected by the unit showed wear after playing.

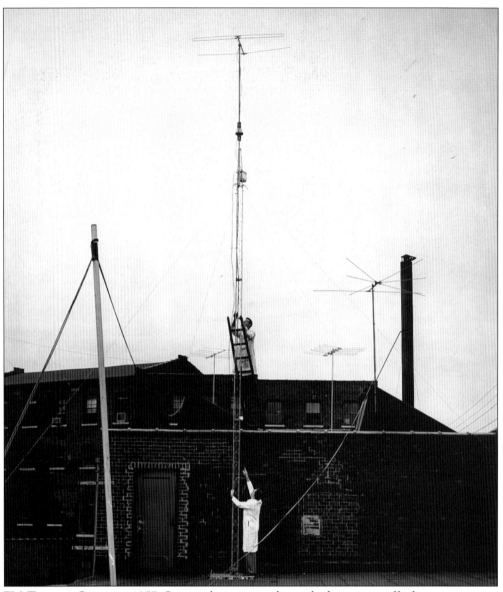

FM TUNERS, OCTOBER 1957. Seemingly precariously perched, testing staff adjust an antenna that was installed on top of the roof of the *Consumer Reports* testing laboratories to monitor FM broadcasts. Indoors, the antenna was hooked up to an oscilloscope to monitor signals.

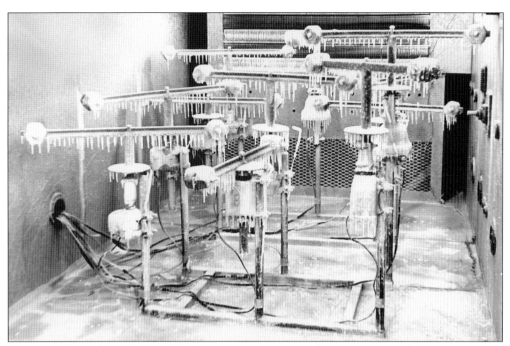

ANTENNA ROTATORS, JULY 1973. To test these rotators' ability to turn freely in severe winter conditions, technicians created heavy icing conditions in an indoor environmental chamber. Of the 11 tested, all but 1 model had adequate turning force to break free when coated with ice. Nine of the models also tested good or very good for accuracy, which was the ability to point in the direction indicated by the pointer on the control-box dial.

ROTATORS FOR TELEVISION AND FM ANTENNAS, JANUARY 1961. An engineer sets up rotators on the roof of *Consumer Reports*' former home in Mount Vernon, New York. Since only the rotators, not the actual antennas, were being tested, creative staff substituted metal rings (designated as having the same moment of inertia as a typical antenna) for actual antennas to save on space and allow for more models to be tested.

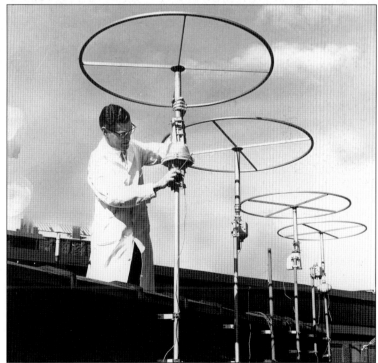

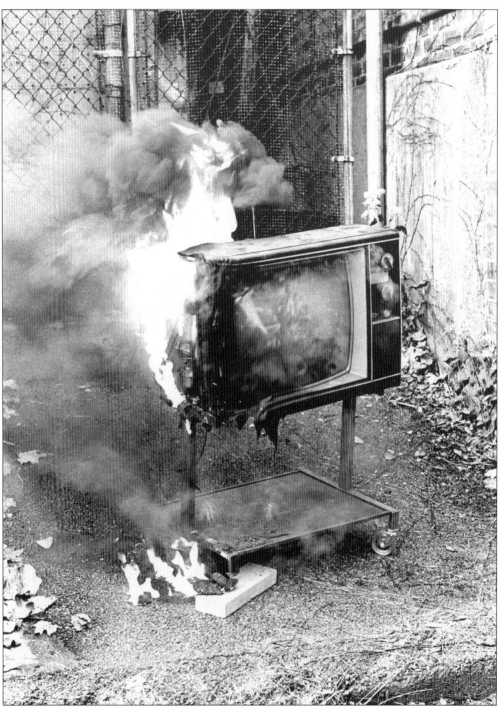

NINETEEN-INCH COLOR TELEVISIONS, JANUARY 1975. A television set was deliberately set on fire outside *Consumer Reports'* laboratories to demonstrate the flammability of plastics used for the cabinet. The burning cabinet threw off chocking fumes and dripped globs of flaming material on the ground. Faced with this frightening situation, *Consumer Reports* called for television cabinets to be made of materials that stopped fire.

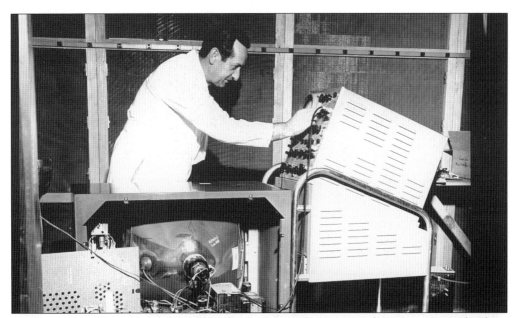

TWENTY-THREE-INCH TELEVISION SETS, FEBRUARY 1962. In a special screening room that kept out interfering signals, an engineer checks the effectiveness of a television's circuit in keeping output steady while the strength of the signal varied. In the tests, *Consumer Reports* found that most sets suffered from some picture distortion. While all were judged acceptable, only three were recommended.

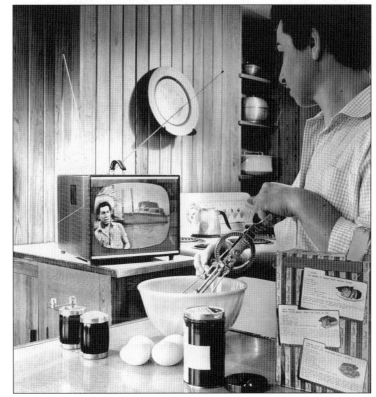

FOURTEEN-INCH PORTABLE TELEVISION SETS, JANUARY 1957. In a picture that could be called a 1950s slice-of-life, a woman glances at a television while preparing dinner. The report stated that while 250,000 14-inch units had been sold in a year, most manufacturers had been focusing on 8.5- to 10-inch screens.

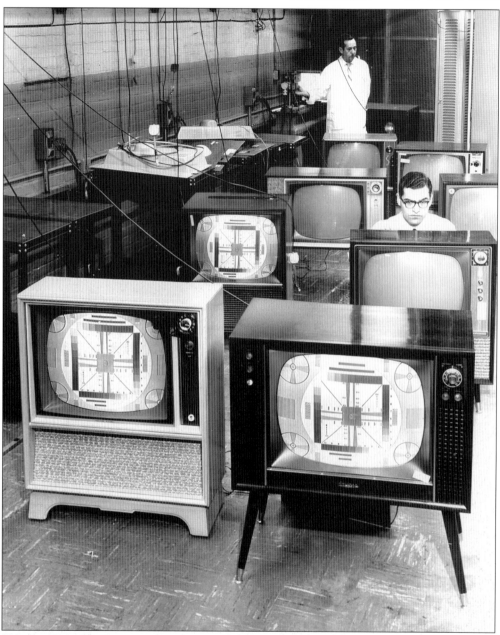

"Minor Brand" Television Consoles, March 1960. A technician pops up from behind a sea of test patterns in this photograph, which was used for a report on eight brands of televisions with limited distribution. *Consumer Reports* chose to test these brands because of the many letters received from readers seeking information about such sets. The tests found no hidden television treasures and even one model was rated not acceptable because of a potential shock hazard.

Nineteen-Inch Portable Television Sets, November 1962. A technician closely examines a television screen for quality in a test of 14 low-priced models. Picture quality was assessed based on crispness, detail, focus, horizontal linearity (objects should not change width as they cross the screen), and the absence of pincushion distortion (titles and rectangular objects should not be curved). The popularity of the sets was attributed to a lower price and smaller size (compared to the popular 23-inch models). The sets performed well in the same tests that were used to evaluate larger and more expensive sets.

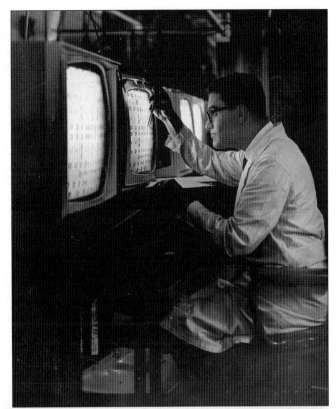

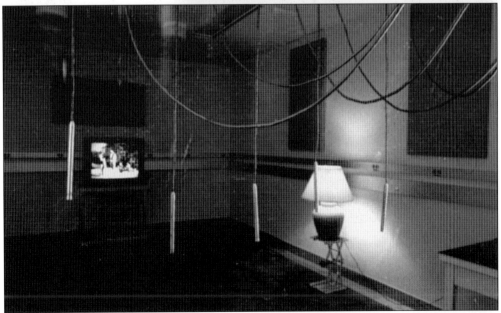

Guide to the Gear, March 1992. Televisions were tested in a room especially designed to mimic the acoustic characteristics of a typical living room. Microphones in the foreground sampled sounds at a distance where viewers were likely to sit. This room was also used for human listening tests of televisions and loudspeakers.

LOW-PRICED MOVIE CAMERAS, NOVEMBER 1972. Aimed at the casual moviemaker, this report found that for under $100, consumers could purchase cameras that ran the gamut from the very simple to the very complex. While all the cameras were judged acceptable, testers recommended three particular models that performed better than the others. This photograph shows how to attach a light to the camera—a feature on all but two of the products tested.

LIGHTS, CAMCORDERS, ACTION, NOVEMBER 2000. In this report on camcorders, testers found a wide range of overall performance. In the above photograph, a technician demonstrated how certain cameras required image stabilizers to remove some of the shakiness. In tests, camcorders were hooked up to a machine that shook them at specific speeds and intensities.

RANGEFINDER 35-MILLIMETER CAMERAS, NOVEMBER 1962. Through a clever montage, this photograph demonstrated some shortcomings of a poorly rated camera. Instead of having a single lever to advance the film and cock the shutter, this model required a button to be pressed, a knob to be turned, and a lever to be depressed before users could press the shutter release. Mechanical performance of this model was rated poor although optical quality was rated good. This model cost $64.95, but prices of models in the tests ran from $29.95 to $99.50 with the top-rated camera costing $79.95.

SLR 35-MILLIMETER CAMERAS, FEBRUARY 1967. This camera test demonstrates one of the reasons why the Miranda Sensorex received an excellent rating for ease of use. The camera, when fitted with a waist-level viewfinder, made kneeling for lower-level shots unnecessary. The camera garnered the top ranking of the 14 models tested and at $249.95 was competitively priced.

PHOTOELECTRIC EXPOSURE METERS, JULY 1955. For this article, *Consumer Reports* tested 27 meters and found major differences in accuracy and sensitivity as well as in other factors such as convenience, adaptability to different uses, and legibility of the scales and computers. Testing included moving meters back and forth along an optical bench with a calibrated light source at one end to determine accuracy at different levels of illumination.

EXPOSURE METERS, NOVEMBER 1959. Four years after the test on the previous page, technicians tested exposure meters again for accuracy. Carefully calibrated test lamps were mounted on an optical bench, and meters that were rated good in accuracy were correct to within one-third stop at midscale and two-thirds stop at the ends of the scale. Meters rated less accurate and those rated poor were off by more than one f-stop or had variable errors across the scale.

LOW-COST HIGH-FIDELITY LOUDSPEAKER SYSTEMS, MAY 1961. Speakers were placed in an acoustic-free field (no echoes) on top of a scaffolding tower to measure frequency and transient responses. The speaker being tested is mounted on a platform that rotated to permit frequency-response measurements.

HIGH-FIDELITY LOUDSPEAKERS, DECEMBER 1958. In *Consumer Reports'* laboratories, loudspeakers were tested for their electrical and acoustical characteristics. Speakers were then tested in an anechoic room using a specially calibrated microphone. In this room, virtually all sound was absorbed by the walls and virtually none was reflected.

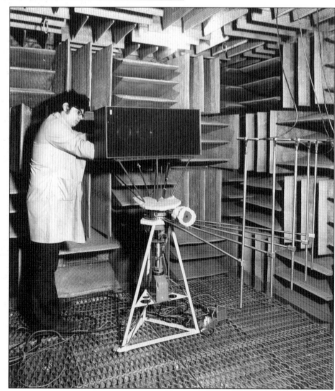

EXPENSIVE LOUDSPEAKERS, FEBRUARY 1974. The anechoic chamber pictured here was used to test speakers in an acoustically neutral environment. Microphones positioned around the speakers recorded sound pressures at various points.

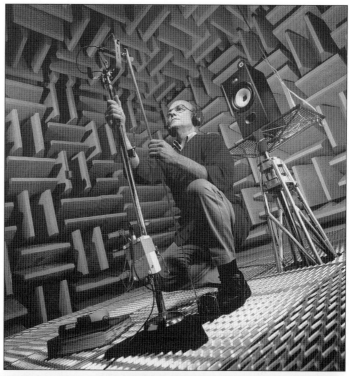

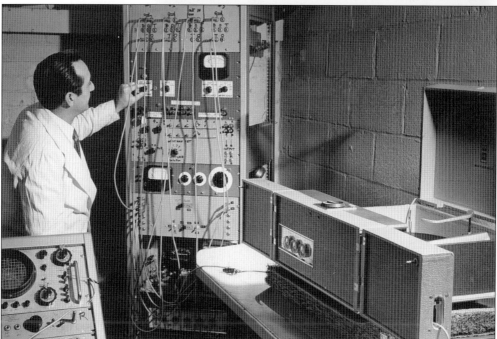

PORTABLE STEREO PHONOGRAPHS, MARCH 1963. A portable phonograph is checked on a meter specially designed by *Consumer Reports* engineers to evaluate the effects of various types of flutter. The report found that while the best of the lot reproduced sound reasonably well, units were rather bulky to tote around despite their portable name.

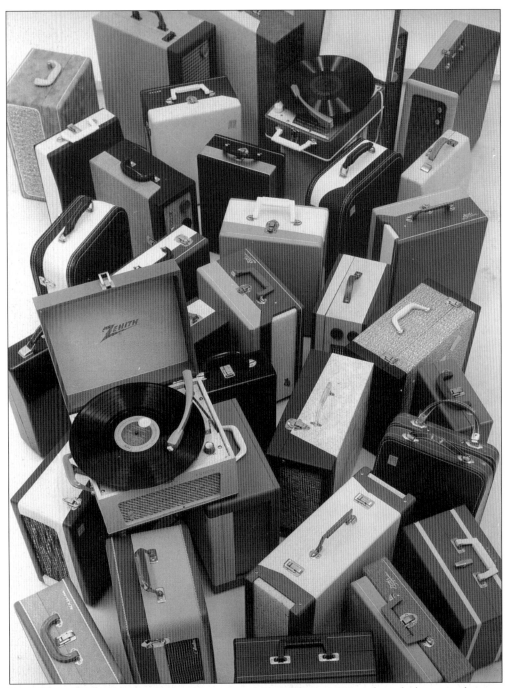

LOW-COST PORTABLE PHONOGRAPHS, AUGUST 1957. In 1956, sales of phonographs rose 44 percent over the previous year, with teenagers accounting for much of the buying public. In this test of 35 portable phonographs, all brands rated mediocre in performance and 7 were rated not acceptable because of the possibility of serious shock hazard.

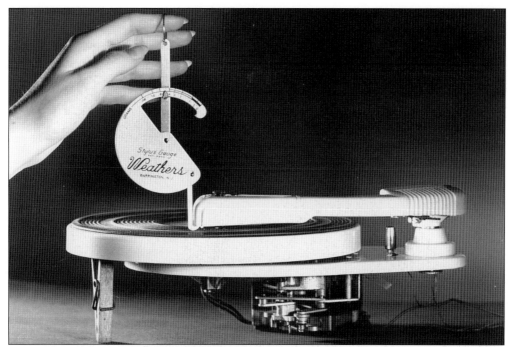

HIGH-FIDELITY PICKUPS, JUNE 1955. In a report on pickups (the small cartridge that holds the needle on a phonograph), 6 of the 26 models tested rated poorly because of problems ranging from fragility to hum sensitivity. *Consumer Reports* also made the point that any system is only as good as its weakest part (often the speakers). In the above photograph, a technician demonstrates how to use a stylus gauge to measure vertical tracking force.

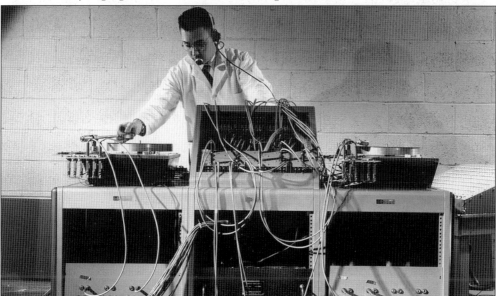

STEREO PICKUPS AND ARMS, MARCH 1959. Looking more like a disc jockey than a technician, a *Consumer Reports* staff member adjusts equipment for testing. This part of the test involved comparing pairs of pickups and arms that were mounted on a console to rate the products' precise control of gain, balance, frequency response, and other factors.

COMPACT DISC PLAYERS, JUNE 1985. In tracking the history of recorded sound, staff created this montage to show the evolution of devices available to consumers. Introduced in 1983 by Sony and selling for $900, CD players had already dropped dramatically in price in just two years. According to the report, a decent player could be purchased for around $300 and discs had dropped in price from about $18 each to $11 to $13 each. The report also explained the difference between analog and digital recordings.

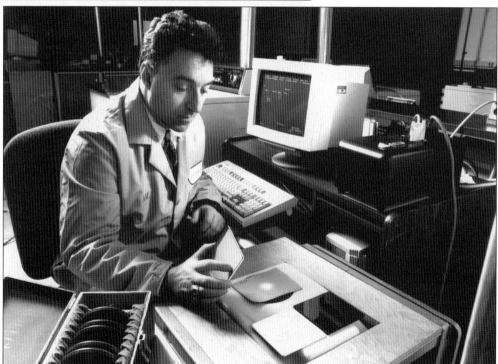

CD PLAYERS, MARCH 1995. With great sound quality in all models tested, *Consumer Reports* chose to no longer score sound when judging CD players. Instead, the article stated, testers focused on model-to-model performance differences that counted when conditions were not perfect or that made programming, playing, and taping faster and easier—such as bump resistance and error correction. Players had again dropped in price with many good brands selling for under $300.

TELEPHONES, DECEMBER 1992. To assess loudness, technicians carried out some complex tests because weak signals can result from at least two common sources—a long transmission line or having more than one telephone off the hook. Testers used plug-in modules, each of which simulates either 1,500 feet or 6,000 feet of telephone line, to determine each telephone's loudness as well as the level of the signal that the telephone sent out to the line.

CELLULAR PHONES, JANUARY 1993. In its first ever report on cellular phones, *Consumer Reports* looked at the system, the service, and 19 lightweight, portable cellular phone models. The article demystified how cellular phones worked and reported on discrepancies in the marketplace—for example, why did the same cellular phone model and service contract cost $209 from one vendor and $1,300 from another.

CALCULATORS, SEPTEMBER 1982. A typical laboratory photograph shows the extent to which *Consumer Reports* will go to provide durability and performance information. Calculators are set up in a laboratory, and the buttons tested mechanically for durability. Not so long ago, the article stated, the basic electronic calculator was a business machine. Today it is more like a disposable flashlight. In 10 years or so, the price of a calculator had dropped from more than $100 to $10 or $15.

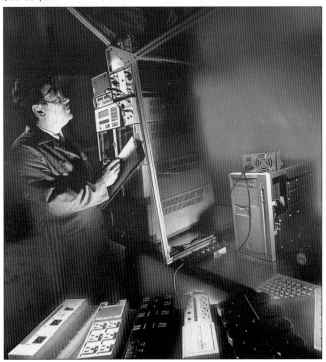

ZAP INSURANCE: SURGE SUPPRESSORS, JANUARY 2000. With home office equipment becoming standard in many homes, and blackouts, power surges, and brownouts commonplace, testers assessed the various surge suppressors available on the market. To determine how typical home-office equipment would fare, testers exposed several unprotected computers to various surges and noted at what point they failed. Then a test computer was connected to each suppressor and fed a variety of 2,000- to 6,000-volt disturbances. The better models protected the computer during more than 1,000 different surge tests.

Nine

THE WORK CONTINUES

ON THE TRAIL OF UNSAFE PRODUCTS,
NOVEMBER 2004. In the introduction to
an extensive report on unsafe products,
Consumer Reports president Jim Guest
wrote how U.S. laws allow for products
banned in this country to be exported
to other countries that are willing to
buy them. While the manufacturers
are supposed to inform the Consumer
Protection and Safety Commission of such
exports within 30 days, *Consumer Reports'*
investigative reporters found that safety
information was buried under a lot of
paperwork and that it took a great deal of
digging to piece together what happened to
banned products. This last chapter shows
how the work of *Consumer Reports* endures
after more than seven decades of ensuring
that consumers have a safe, just, and fair
marketplace. These pictures show how
Consumer Reports continues to be watchful,
paying close attention to detail, innovation,
and safety. Today the organization that
started in a little office in New York City
continues its work under the motto "Expert,
Independent, Non-profit."

INNOVATIVE: LIGHT BULBS, AUGUST 1965. Lamp life was tested on the rack in the background of this photograph, with electricity regulated to a constant 120 volts. Light output was measured when bulbs were new and then again after 500 hours in an integration sphere using a light-sensitive cell.

INNOVATIVE: WET BASEMENT?, JUNE 2002. When testing equipment does not exist or is inadequate, technicians and engineers build their own. To test waterproof coatings for basements, *Consumer Reports* staff built a metal chamber and secured concrete blocks inside that were painted with each coating. The unit was then sealed and pressurized to force water through the blocks and out the portholes on the sides. Note the many samples prepared for testing in the background.

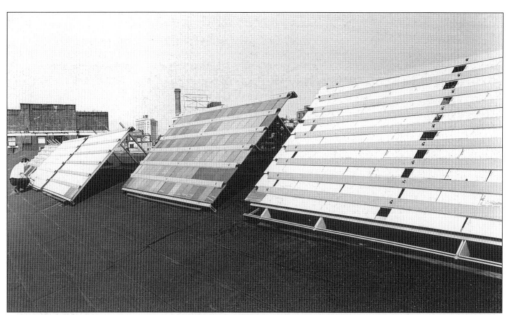

DETAILED: EXTERIOR PAINTS, SEPTEMBER 1976. This 1976 report illustrates the lengths to which *Consumer Reports* will go to ensure that consumers are properly informed. Sections of board were painted with different exterior paints, and the samples were then mounted on racks so that they could be exposed to normal outdoor weather conditions such as rain, snow, sun, and humidity. To ensure that paints were exposed to different conditions, samples were tested in both New York and Florida.

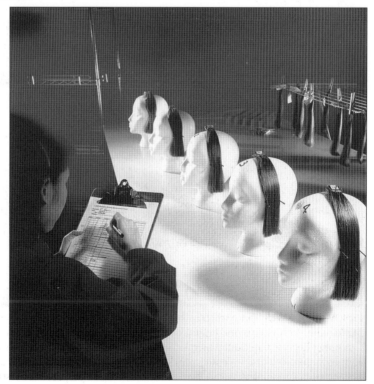

DETAILED: TRESS FOR SUCCESS, SEPTEMBER 2000. To test claims made by shampoo manufacturers about products that add volume to hair, technicians washed locks of human hair with 66 different shampoos, dried them, and then asked panelists and specialist consultants to compare the results. While staff were surprised to find that, in many cases, the normal shampoos increased hair volume more that the brands that claimed to be volumizing, most added little to no volume.

WATCHFUL: CLAIM CHECK, BOWLING FOR BOUNTY, JANUARY 2004. To check on a claim made by Bounty paper towels that wet towels could hold up a bowling ball, *Consumer Reports* testers recreated the advertisement, pitting Bounty against Brawny Pure White with Scrubbing Circles, which, research indicated, was the brand's main competitor.

WATCHFUL: CLAIM CHECK, BOWLING FOR BOUNTY, JANUARY 2004. Testers used a six-pound bowling ball and two sheets of paper towels—as shown in the advertisement—and then poured 150 milliliters of water onto each ball. In the outcome of the test, "Bounty scored a strike" while its competitor did not fare so well.

SAFETY: POWER SAW
POWER, AUGUST 2002.
An action photograph
showing a test of power
saws demonstrates the
safety measures taken by
Consumer Reports staff
when testing potentially
dangerous tools. The report
included information about
what safety equipment to
wear, including eye and
hearing protection as well
as a dust mask. The report
also suggested purchasing
a unit that came equipped
with a blade brake, which
could stop the blade almost
instantly. This photograph
also reflects *Consumer
Reports'* attention to safety
in its own laboratories.

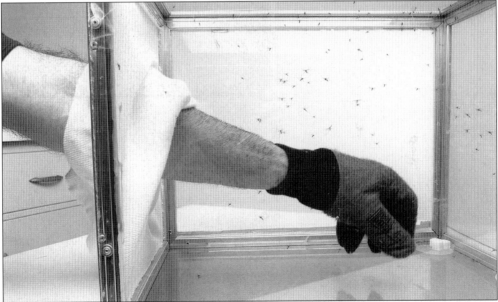

SAFETY: BUZZ OFF, JUNE 2000. With growing concerns about the spread of Lime disease and West Nile virus, *Consumer Reports* staff took on mosquitoes and ticks in this report aimed at helping consumers enjoy the outdoors more safely. In this picture, a tester inserted his arm, to which he had applied repellent for three minutes, into a cage filled with 200 mosquitoes. The tester re-inserted his arm every half hour so that experts could observe and record the number of bites he received and the length of protection each product provided.

THE CONSUMERS UNION AND CONSUMER REPORTS ARCHIVES. All the photographs included in this book are part of the archives of Consumers Union and Consumer Reports. Located at its headquarters in Yonkers, New York, the archives are both a physical space and a collection. The place is a specially designed temperature- and humidity-controlled room with compact moveable shelving and acid-free storage containers. The collection, which documents both the history of the organization and its place in the larger national and international consumer movement, includes materials dating back to the late 19th century—such as hundreds of rare and influential books on consumer issues, personal and professional papers, thousands of photographs, videos, oral histories, artifacts (like testing equipment and products tested), as well as a comprehensive collection of publications produced by Consumers Union and Consumer Reports since 1936.

THE ARCHIVES. The archives support the business of the organization by providing research and materials to answer the needs of public relations, editorial, design, legal, fund-raising, advocacy, marketing, and technical departments. Resources available internally include *First Time Tested* (a list of the first time products were tested) and *Last Time Published* (the most recent report on a given product). The Information Center, the department responsible for the archives, maintains an intranet page that provides information and access procedures for materials in the archives. Every year, scholars from around the world visit the archives to use the vast resources. To date, more than 50 theses, dissertations, and books have been written using this collection.